DRAWINGS OF
MUCHA

"Komenský." 1910.

DRAWINGS OF
MUCHA

70 WORKS BY
ALPHONSE MARIA
MUCHA

DOVER PUBLICATIONS, INC.
NEW YORK

Drawings of Mucha is a new work, first published in 1978 by Dover Publications, Inc. The publisher is grateful to Mr. and Mrs. Eric Estorick of the Grosvenor Gallery, London, for making the original drawings available for direct reproduction.

International Standard Book Number: 0-486-23672-2
Library of Congress Catalog Card Number: 78-52613

Manufactured in the United States of America
Dover Publications, Inc.
180 Varick Street
New York, N.Y. 10014

PUBLISHER'S NOTE

The general outlines of Mucha's career are well known by now. Born in 1860 in the Moravian area of what is now Czechoslovakia, he displayed considerable artistic skill while still a child. His local instruction and his early commissions for noble patrons confirmed his ecclesiastical and feudal-romantic bent. His quest for formal training took him to Munich (1885), where he was molded by the solid academic tradition of draftsmanship and by the fashion for flamboyant allegory, and to Paris (1887), where the stipend from his patron came to an end and he was compelled to do illustration and other commercial art work for a living. Everyone knows how Sarah Bernhardt's commission for a poster in December 1894 proved to be the turning point in Mucha's career—although the *Gismonda* poster did not, as is often stated, represent a totally new phase in his art, the main lines of which remain remarkably consistent throughout his life.

From 1895 to 1904 Mucha not only continued to work for Bernhardt, but was also one of the most fashionable designers in Paris, swamped with orders for advertising art, illustrations, designs of ornamental objects and even buildings, and also for purely decorative pictures—the so-called *panneaux décoratifs*.[1] In that era of hothouse woman-worship, his dreamy but full-blooded female figures—an unnerving amalgam of Slavic peasant girl and the Queen of Heaven—successfully challenged the earlier modes of Eugène Grasset's pallid stained-glass damozels and Jules Chéret's frisky playgirls. Moreover, Mucha's ingrained predilection for Baroque curves and swirls, together with his taste for near-excessive patterning and ornamentation, and for obsessively hieratic repetition–rows of similar flowers or insects succeeding one another in a picture border as saints are successively invoked in a litany—made him one of the archpriests of the Art Nouveau cult of those years.

In 1904 Mucha made the first of his six trips to the United States, where he painted and lectured. It was a New York industrialist who financed *The Slav Epic*, a cycle of twenty historical paintings on which the artist worked until 1930. Always a serious painter at heart, Mucha could now settle down in Czechoslovakia and work for himself and his nation as he saw fit. His Slavic cycle was more appreciated at home than in Western Europe and America, because tastes in art were no longer favorable to the academic tradition to which the artist still adhered. Mucha died in 1939.

Whereas the products of Mucha's Parisian period, especially his great posters, are now often seen, though usually in indifferent reproductions, his original drawings, done in a variety of media, are not yet as widely known as they deserve to be. Naturally, many of them are interesting because they reveal the first, or intermediate, thoughts for famous printed or painted works. But more basically than this, they show that his draftsmanship—highly admired by even such a difficult connoisseur as his contemporary Whistler—was the firm and brilliant underpinning of his entire craft. Moreover, it should be recalled that the actual posters and *panneaux décoratifs* were printed by others, professional lithographers, from Mucha's instructions and that after the first couple of years of his immense

[1] These pictures of girls and plants, which have been described as posters without an advertising text, were lithographed on heavy paper or silk and were hung on walls or used as screens.

popularity he was simply too busy to supervise the printing personally; on top of this, his own printers at the time—like so many today—disseminated reduced, imperfect copies of his printed works which traduced the real quality of his art. These considerations make the original drawings essential for the proper evaluation of Mucha's standing.

It is fortunate that the drawings in the present volume represent so many areas and high spots of Mucha's activity. After a pre-Bernhardt Paris illustration (page 1), we find several works done for the Divine Sarah (pages 4, 5, 11, 28); a wide variety of advertising and packaging art for many different products; many sketches for *panneaux décoratifs*; important book and magazine illustrations, especially one for the 1897 *Ilsée* (page 17), a book justly regarded as a summa of Mucha's decorative art and a precursor of the numerous Art Nouveau style books; studies (pages 37, 40, 41, 51) for Mucha's two major portfolios of ideas for artists, the *Documents décoratifs* of 1901 and the *Figures décoratives* of 1905; a sample of commercial work done on a trip to the United States (page 54); and some of the late work, including two sketches for a *Slav Epic* painting (page 57) and a watercolor of 1936 (page 56).

In regard to pictorial structure and iconography, the present selection exemplifies such basic traits of Mucha's art as the overwhelming importance of the circle, both as an underlying structural element (pages 26 and 35) and as a part of the finished composition, where it often serves as a halo (pages 11, 17, 18, 19, 21, 23, 27, 30, 34, 39, 43, 49); the predilection for arched tops (frontispiece, pages 22, 25, 42, 55, 56 and the first color page); his skill with border elements (page 39 and the first color page); his use of folk embroidery motifs (pages 13, 26, 27), six-pointed stars (6, 11, 15, 19, 30) and what was called "macaroni hair" (11, 13, 15, 17); his mysterious female giants, both Virgin Mary and Earth Mother (6, 17, 30, 33); and his dark Catholicism, mixed with Masonic and Rosicrucian beliefs (6, 8, 19 and the seventh color page).

An insight into the artist's working habits and into the painstaking preparation of his pictures is afforded in this book by the inclusion in several instances of more than one stage in the genesis of a given work. Thus, we have both a charcoal contour sketch (page 7) and the finished tempera color sketch (fifth color page) for the *panneau décoratif* "Autumn"; a charcoal and pencil study for the lithograph "Salammbô" (page 14) alongside a printed proof (page 15) of the black-and-white contours which the artist has colored in by hand as a guide to the color printing; the drawing for the *panneau décoratif* "Ivy" alongside the printed *panneau* (pages 38 and 39); two stages in the work on a cover for the magazine *L'Habitation pratique* (pages 48 and 49); and an early sketch for the St. Louis World's Fair poster (page 53) in addition to the completed poster (last color page).[2]

[2] In order to allow such comparisons, and in order to illustrate three other outstanding pieces, we have included six items in this volume that are printed matter rather than drawings: pages 11, 13, 15, 39 and the first and last color pages.

LIST OF ILLUSTRATIONS

The dimensions are expressed in inches, height before width.
The color section follows page 18.

COLOR

BLACK AND WHITE

DRAWINGS OF
MUCHA

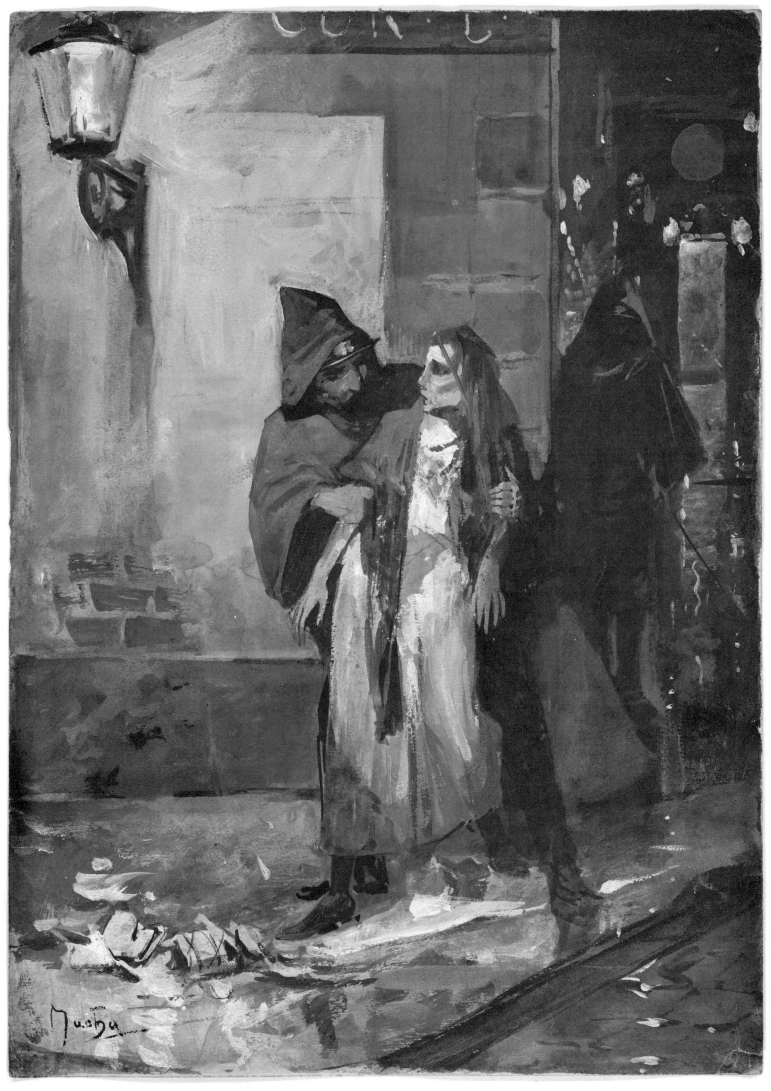

Prostitute apprehended by a policeman. Drawing for a book illustration. 1893.

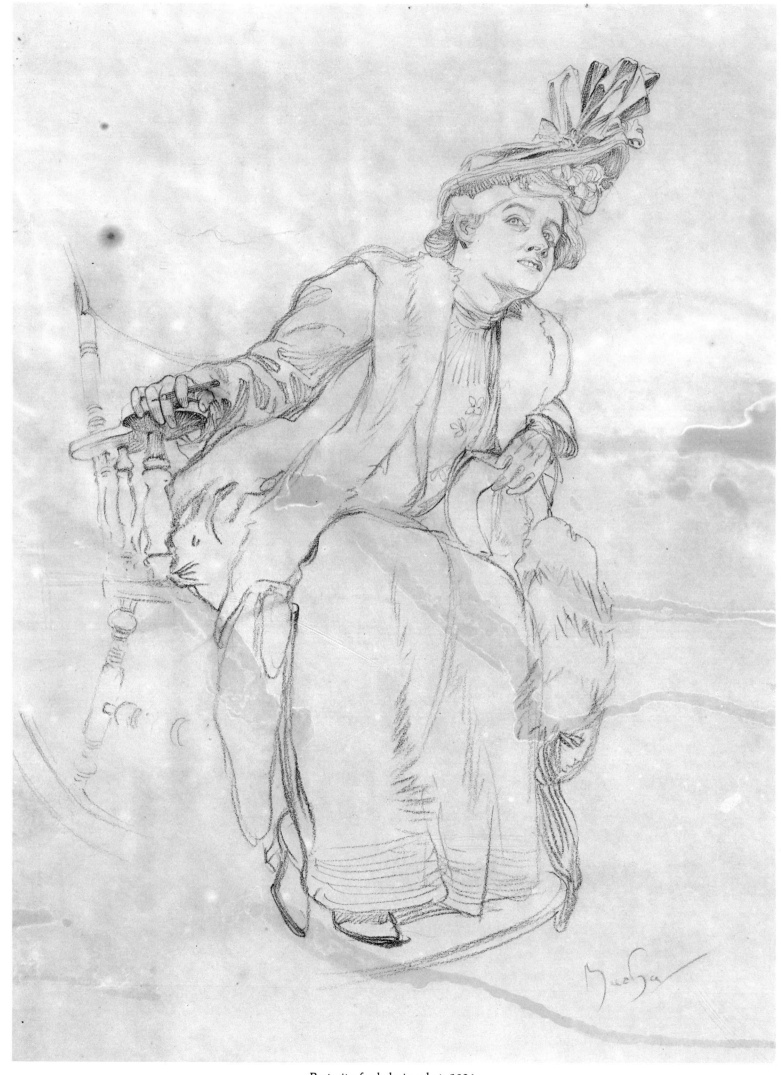

Portrait of a lady in a hat. 1896.

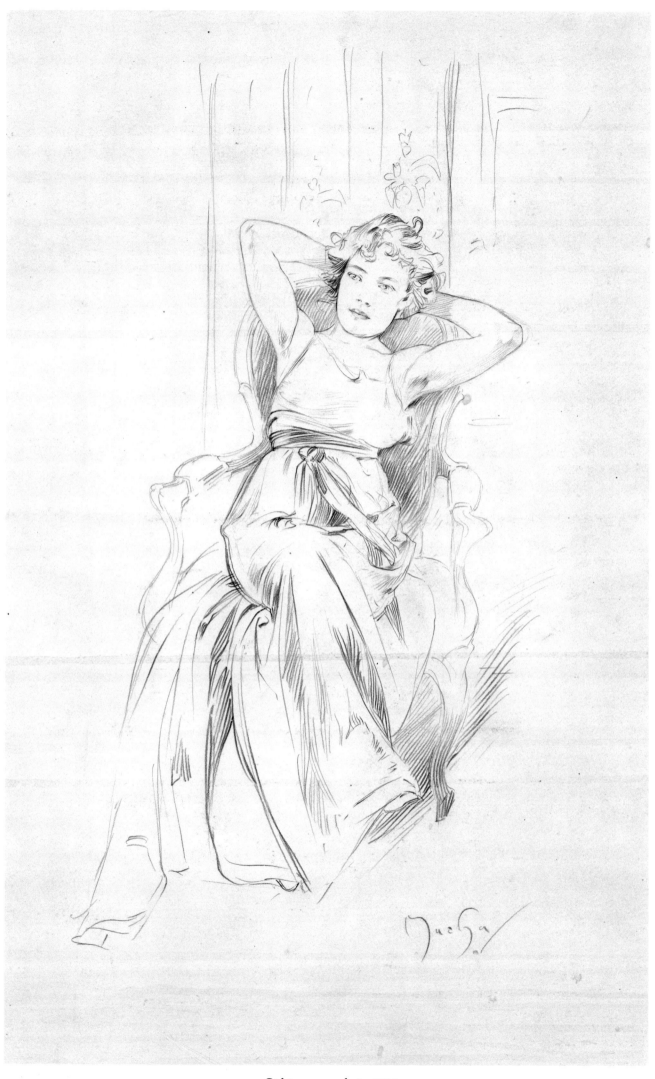

Girl in an armchair. 1896.

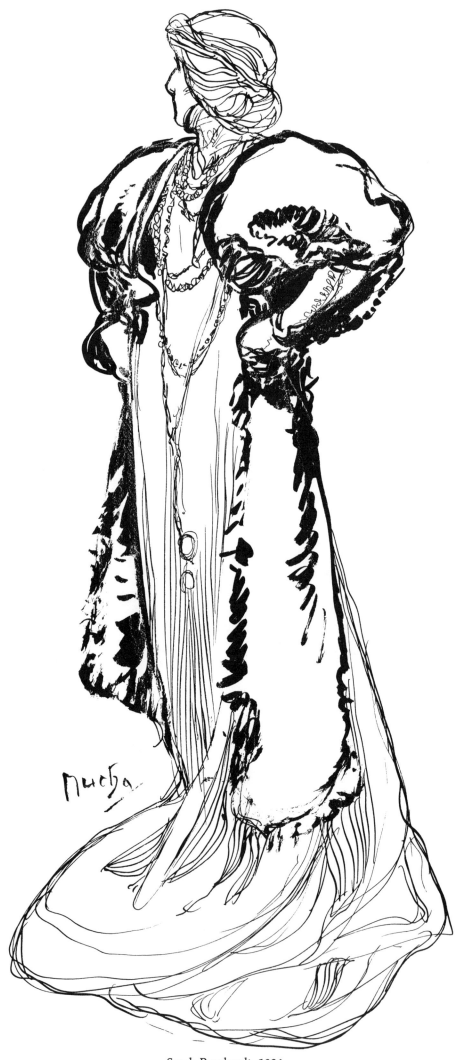

Sarah Bernhardt. 1896.

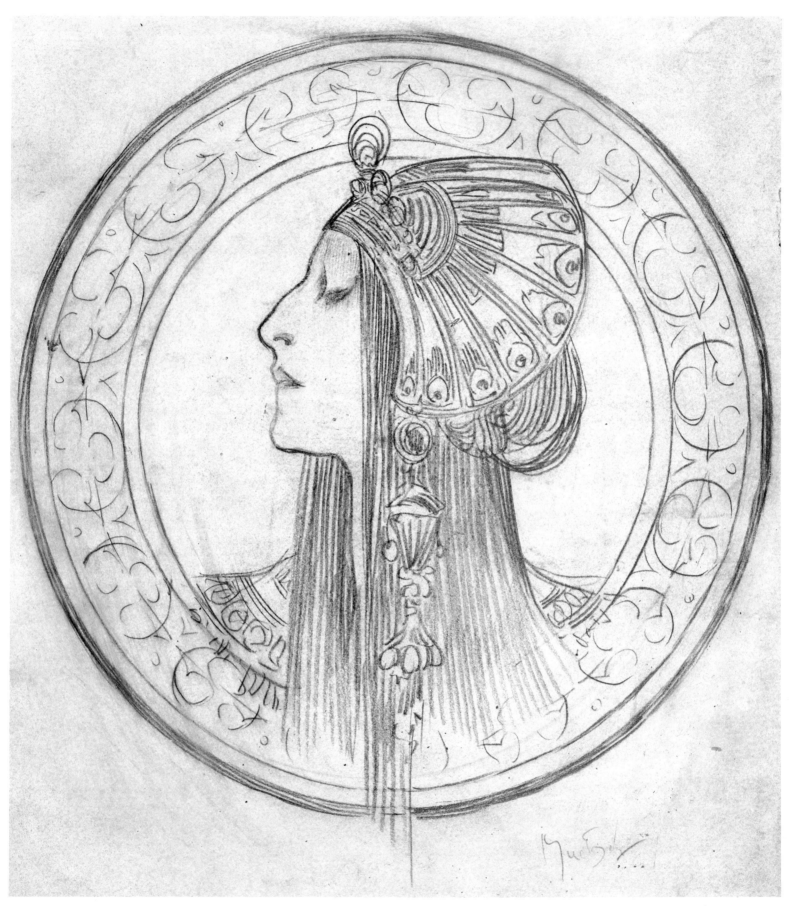

Sarah Bernhardt wearing a tiara. 1896.

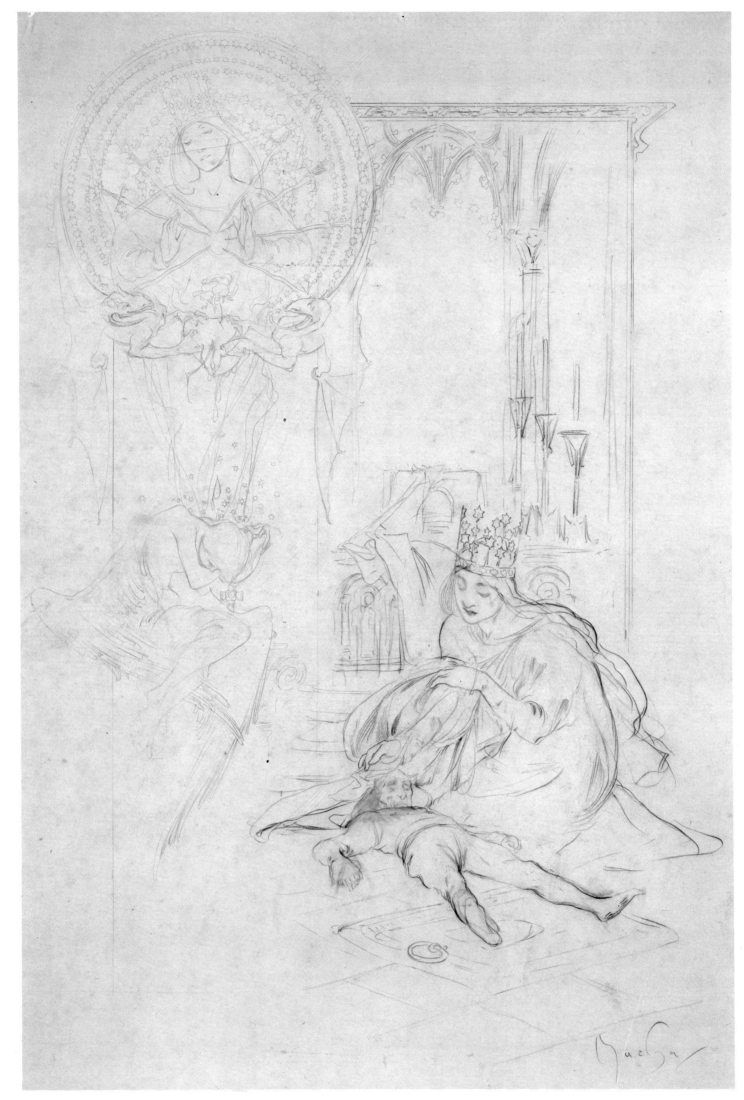

Sketch for an illustration in *Le Rat*. 1896.

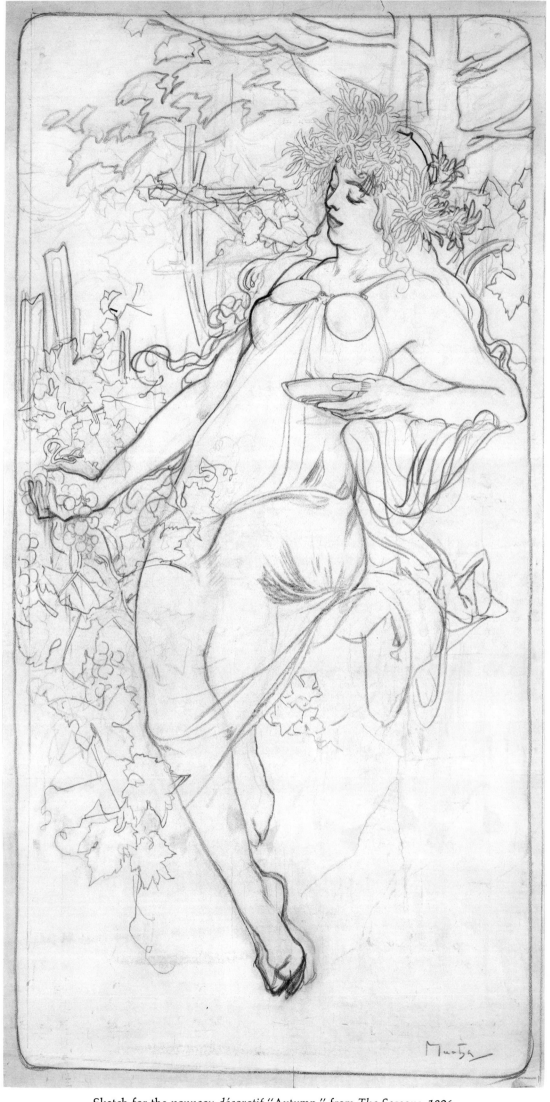

Sketch for the *panneau décoratif* "Autumn," from *The Seasons*. 1896.

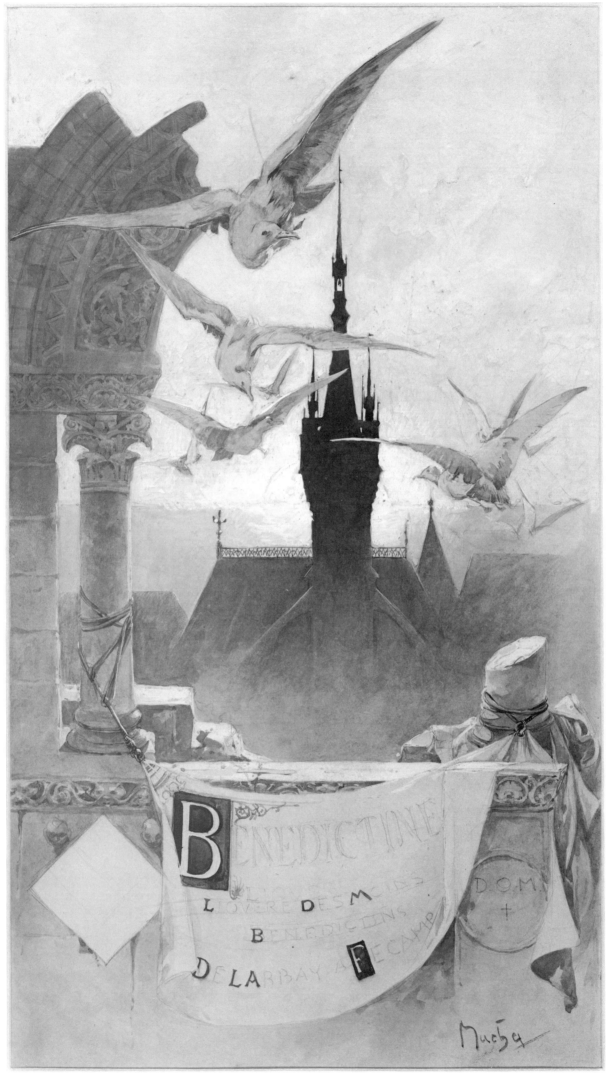

Drawing for a Benedictine liqueur poster. 1896.

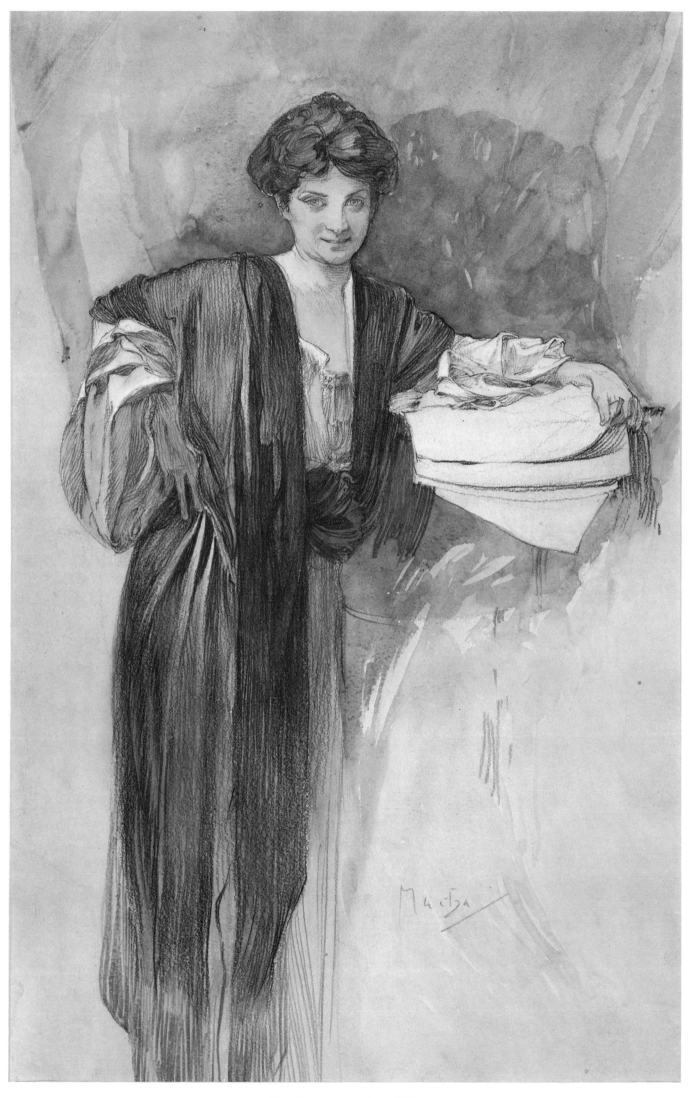

Standing woman. Late 1890s.

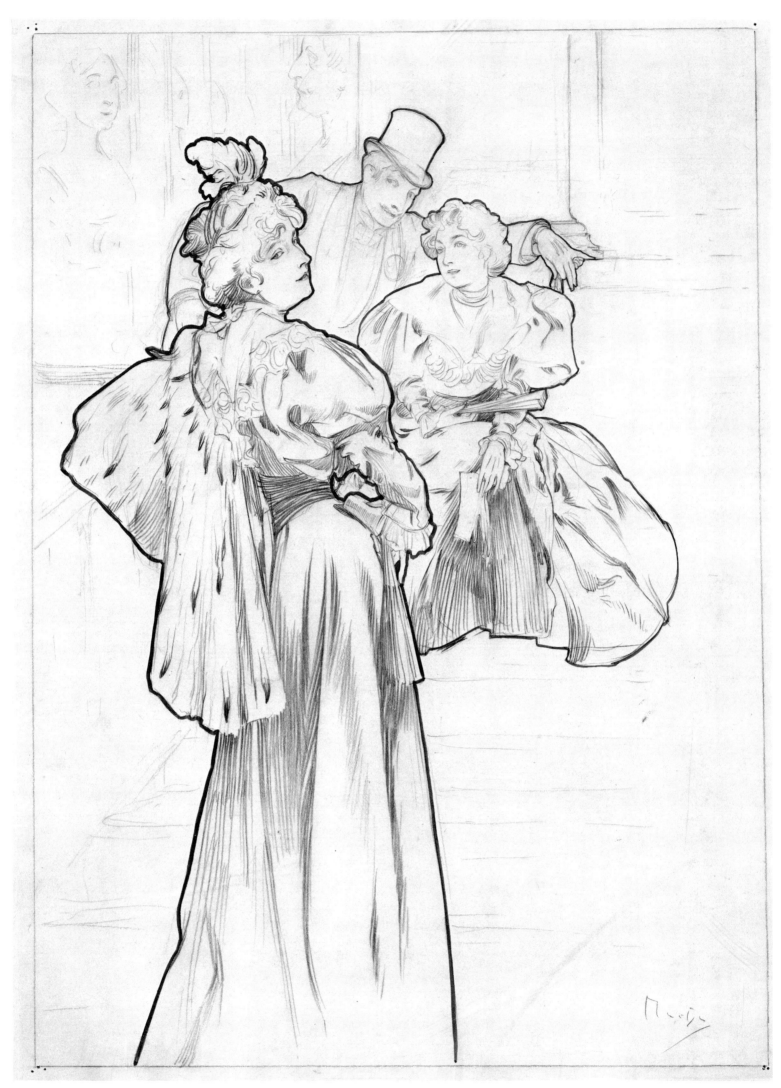

"In the Foyer of the Comédie Française." By 1897.

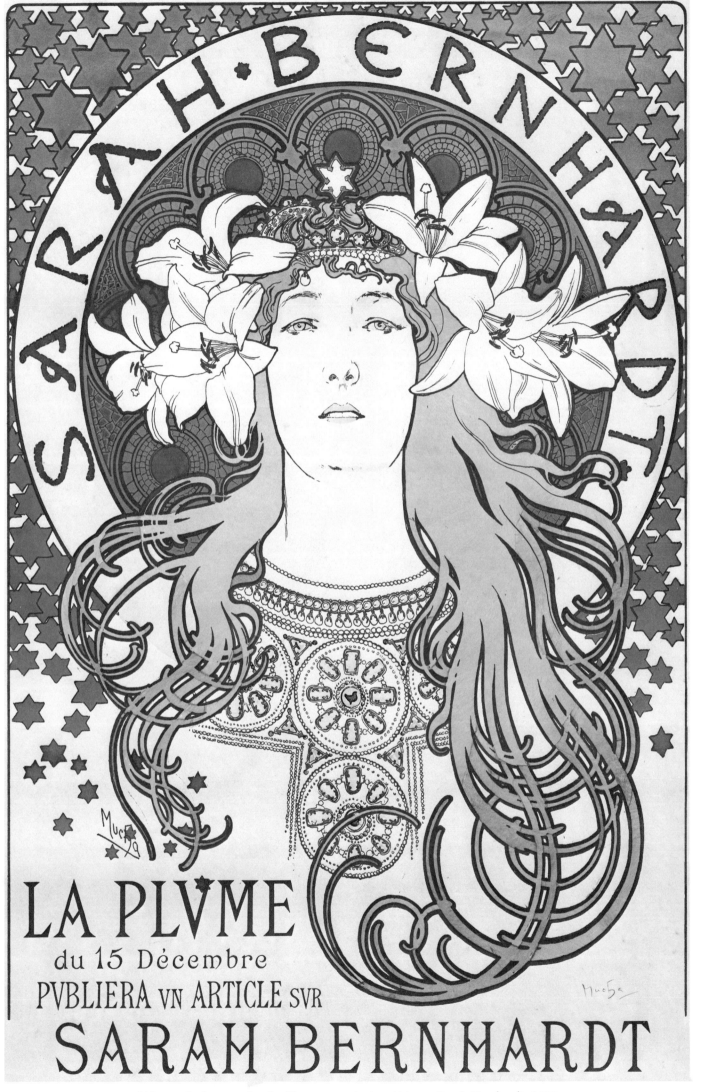

Lithographed poster for *La Plume* magazine's article on Sarah Bernhardt. 1896.

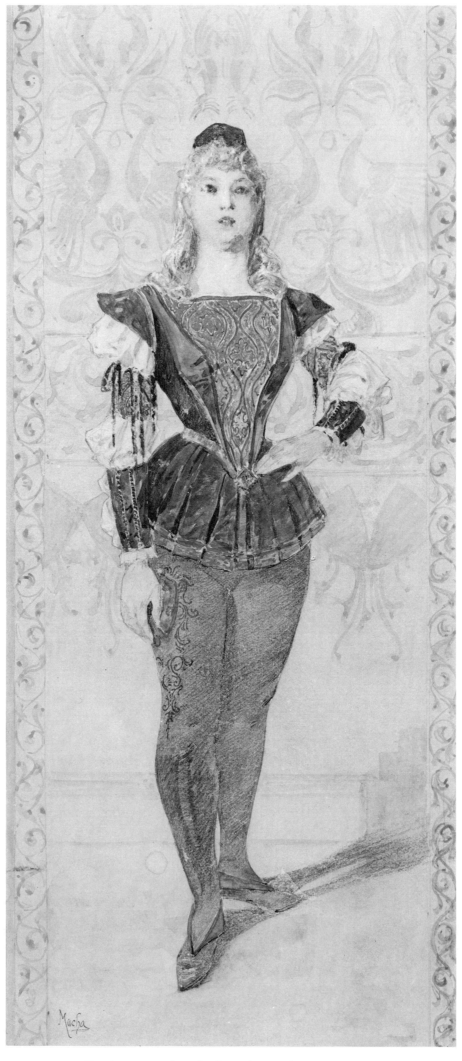

Page's costume for a book on theatrical costumes. 1897.

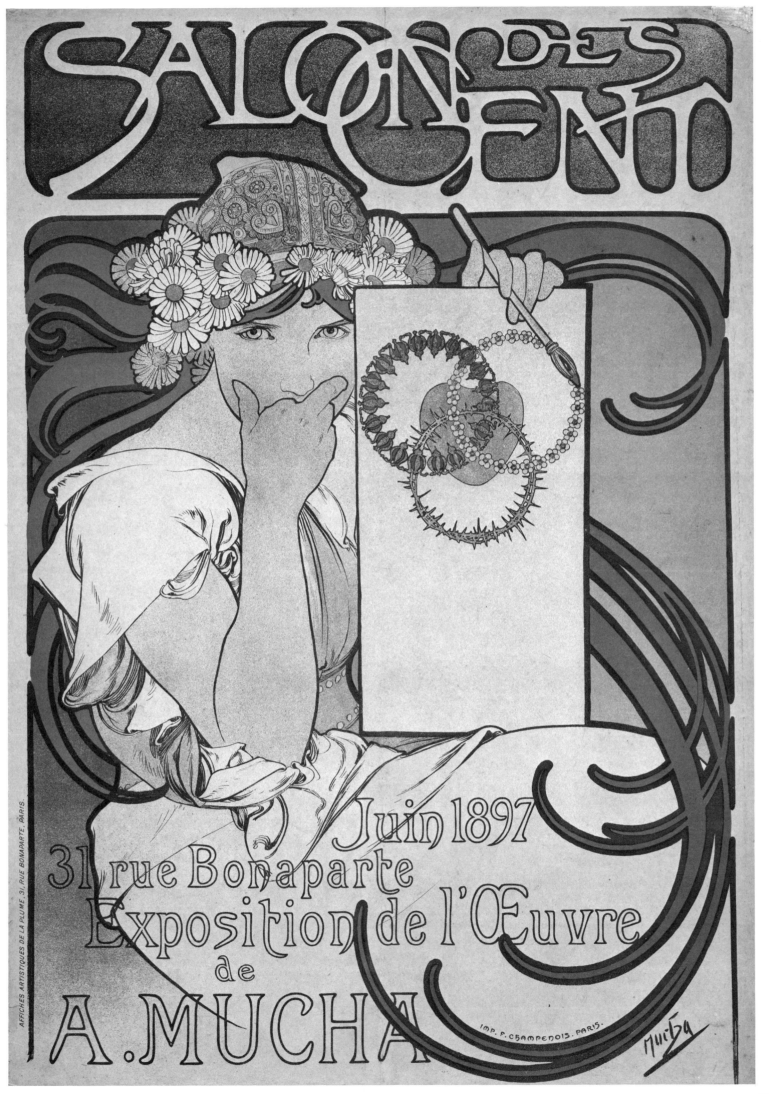

Lithographed poster for Mucha's show at the Salon des Cent. 1897.

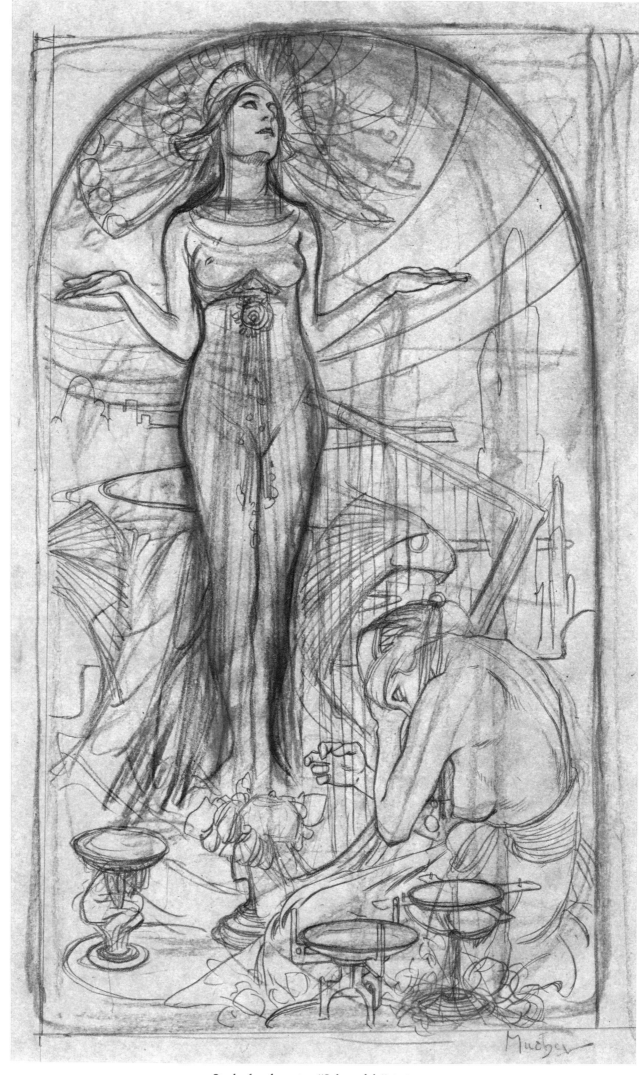

Study for the print "Salammbô." 1897.

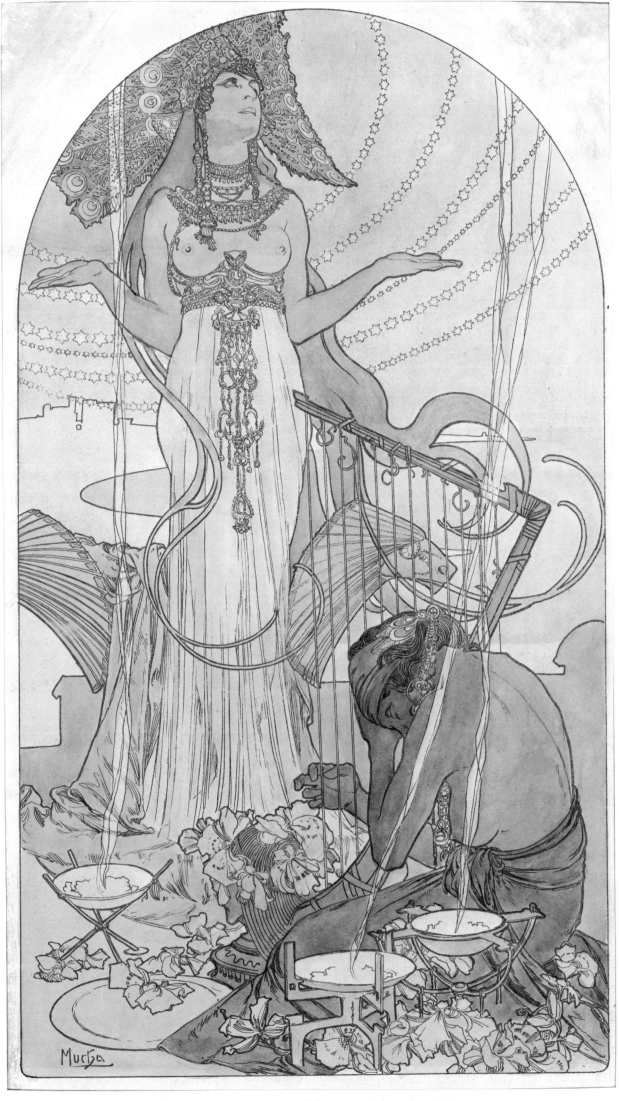

Hand-colored impression of the print "Salammbô." 1897.

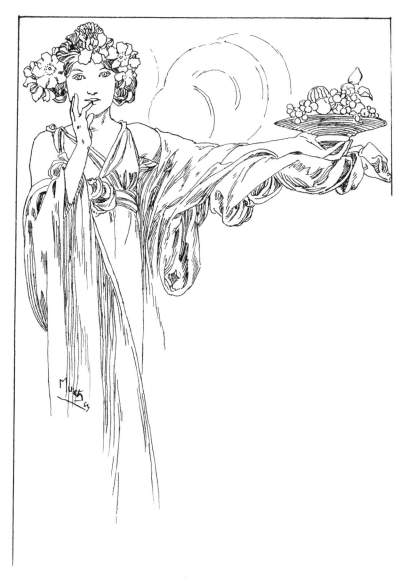

Drawing for a menu. 1897.

16

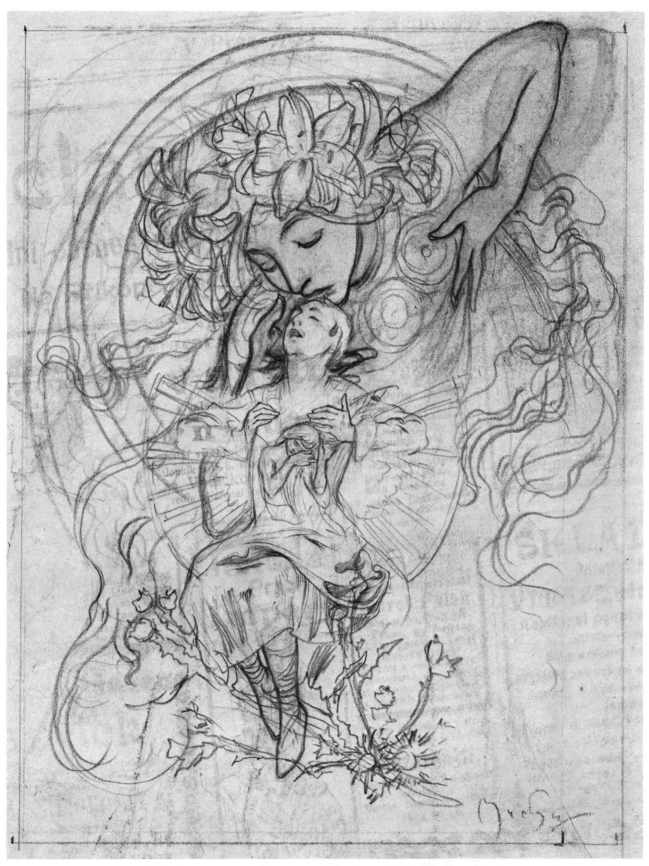

Sketch for an illustration in the book *Ilsée, Princesse de Tripoli.* 1897.

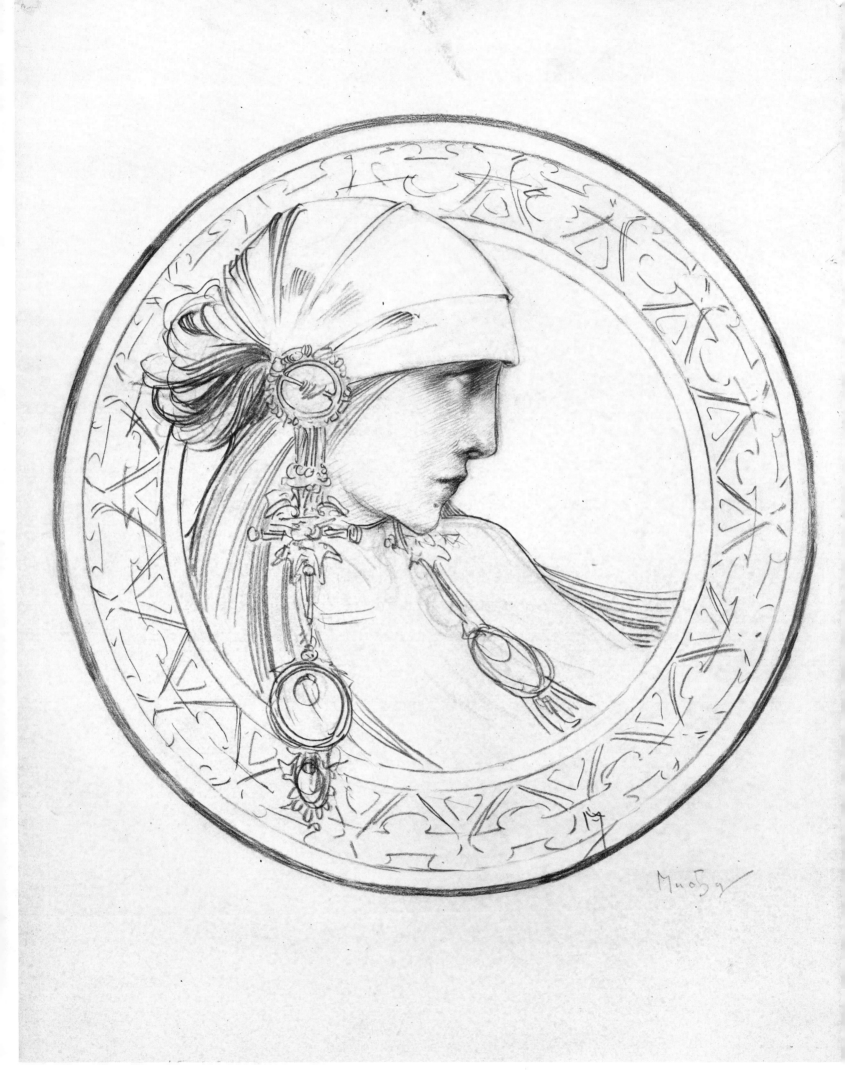

Profile of a woman wearing jewelry. 1898.

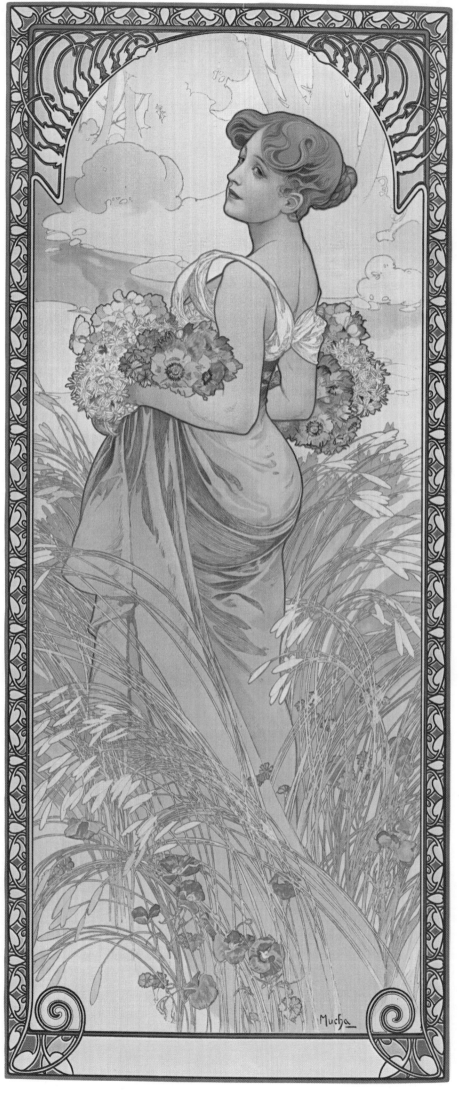

Girl in a grainfield with field flowers. *Panneau décoratif*, lithographed. Late 1890s.

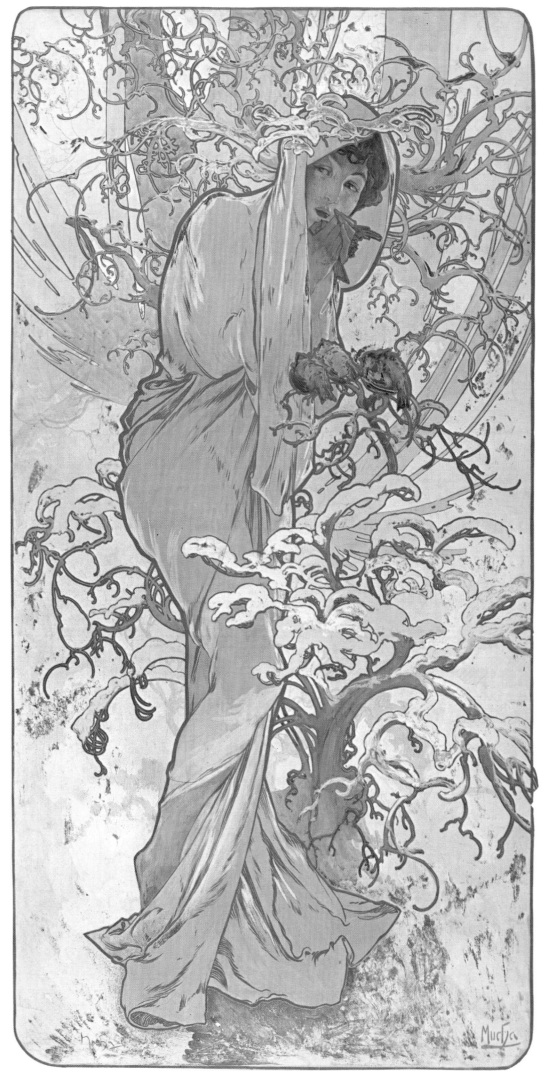

Preliminary drawing for the *panneau décoratif* "Winter," from *The Seasons*. 1896.

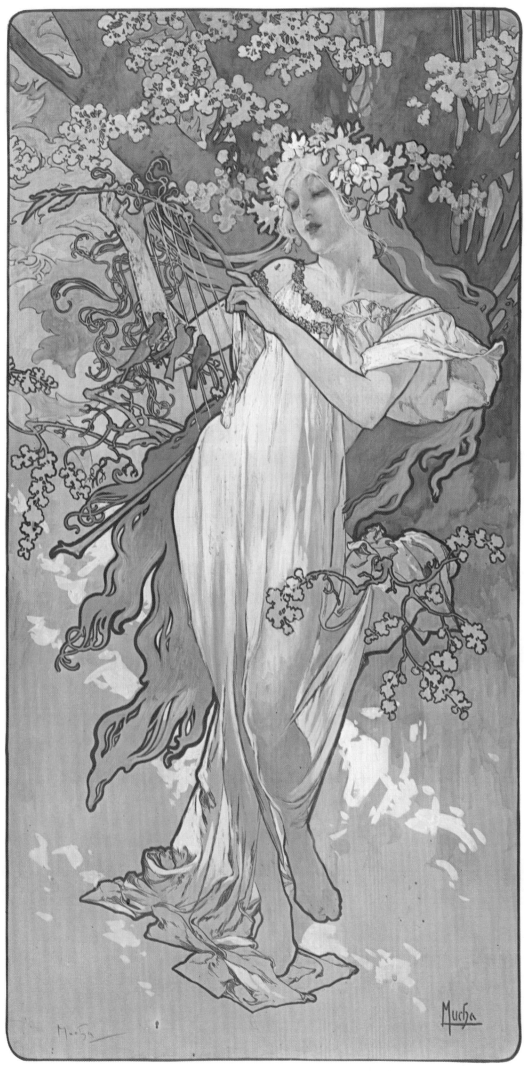

Preliminary drawing for the *panneau décoratif* "Spring," from *The Seasons*. 1896.

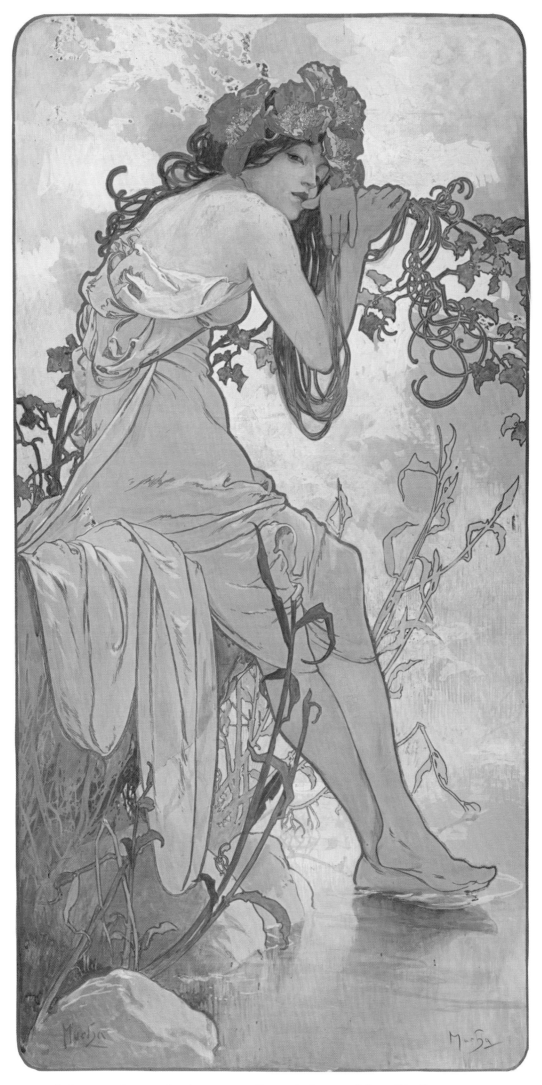

Preliminary drawing for the *panneau décoratif* "Summer," from *The Seasons*. 1896.

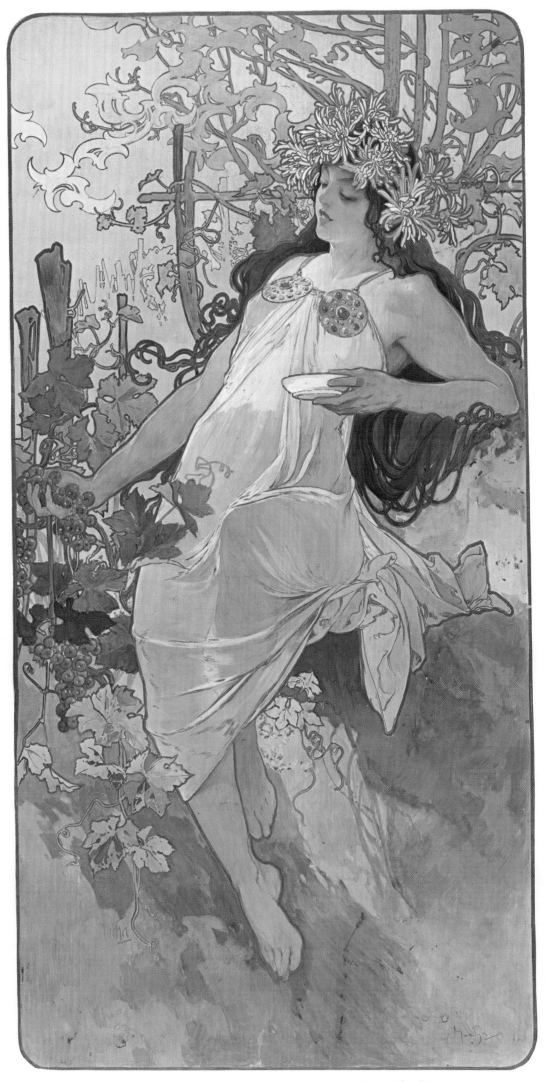

Preliminary drawing for the *panneau décoratif* "Autumn," from *The Seasons.* 1896.

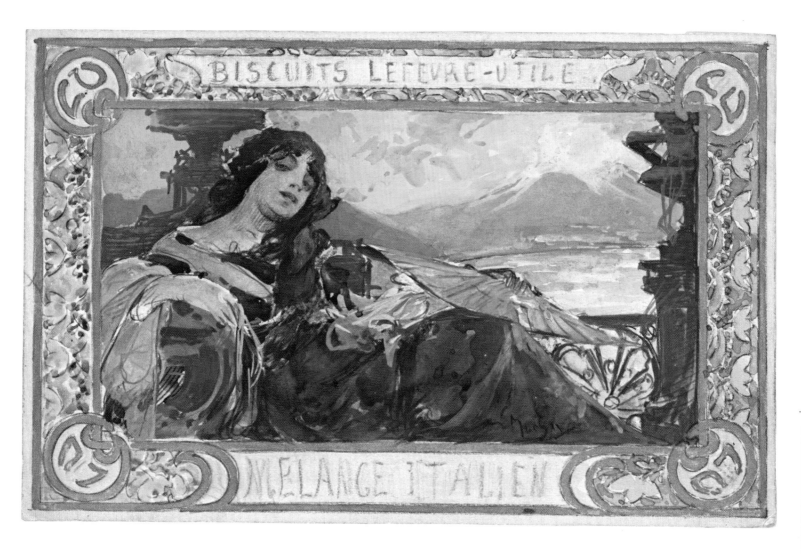

BISCUITS LEFÈVRE-UTILE

MÉLANGE ITALIEN

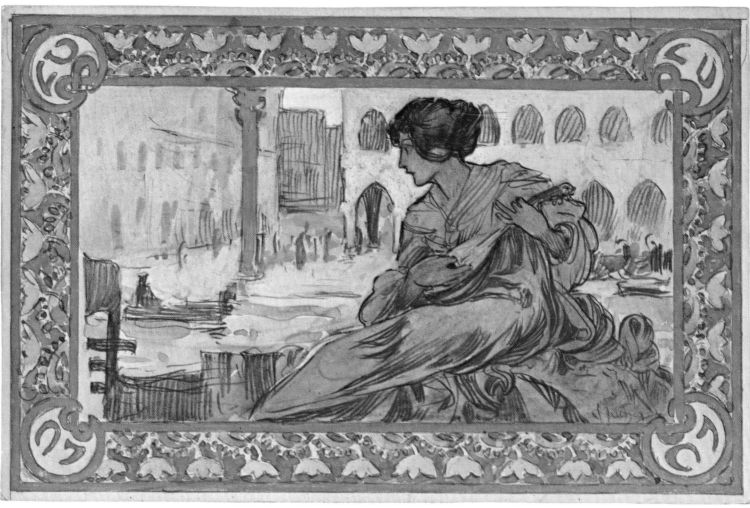

Sketches for Lefèvre-Utile biscuit boxes with scenes of Naples and Venice. 1897.

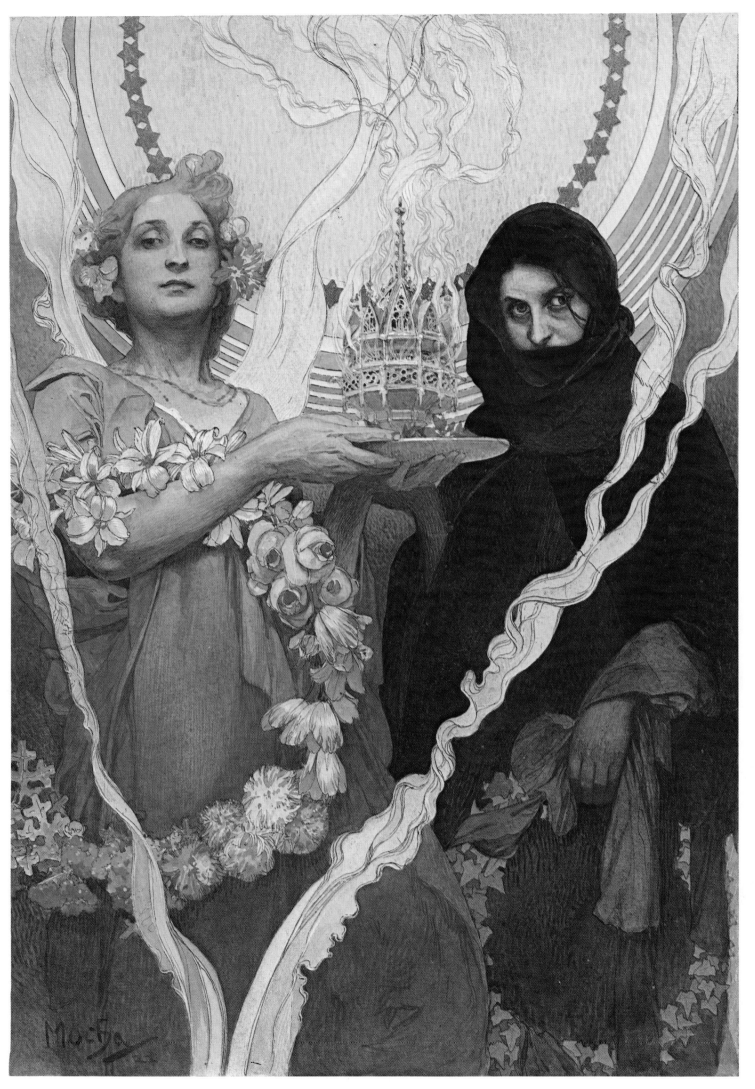

Drawing for the Thanksgiving cover of *Collier's* magazine, 1922.

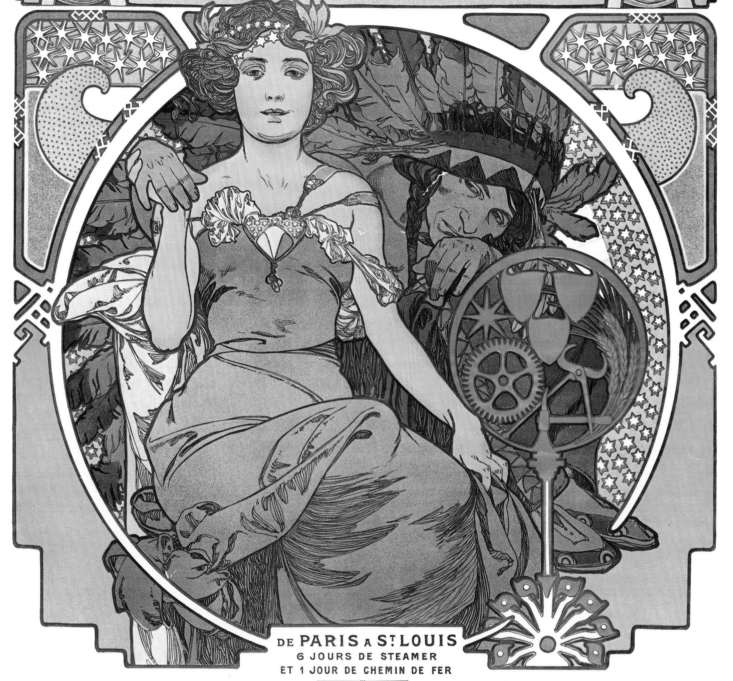

Lithographed poster for the 1904 St. Louis World's Fair. 1903.

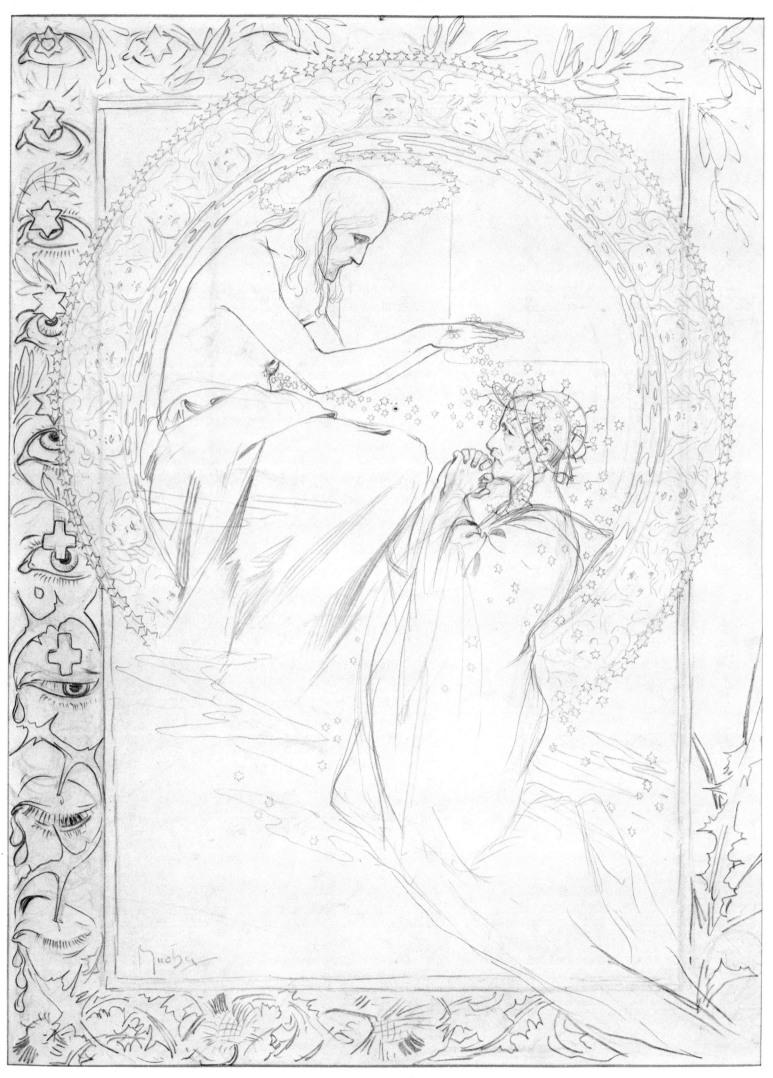

Sketch for a *carte-souvenir* in memory of the late King of Naples. 1897.

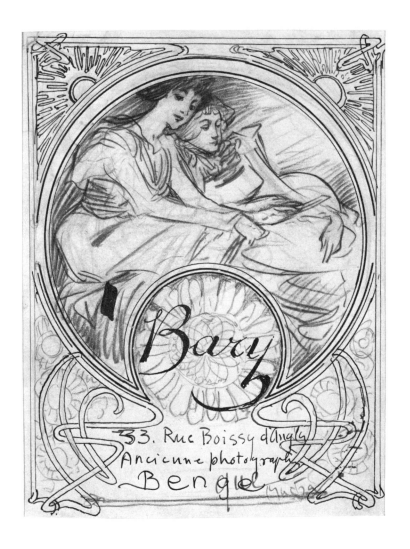

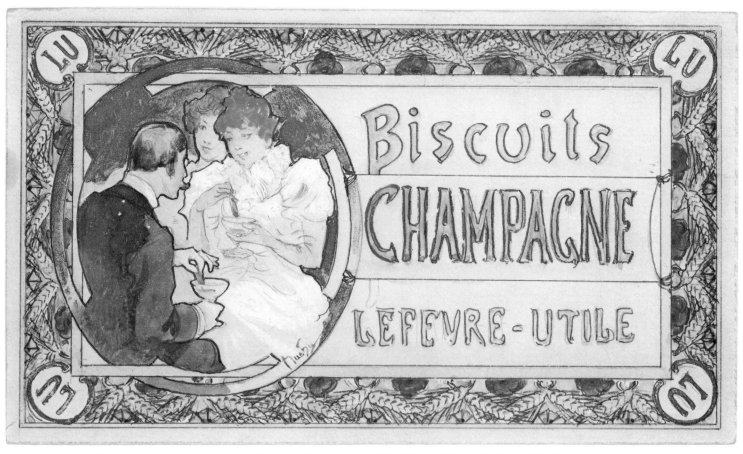

Sketches for the photographer Bary's advertising card (1899) and for a Lefèvre-Utile biscuit box (1897).

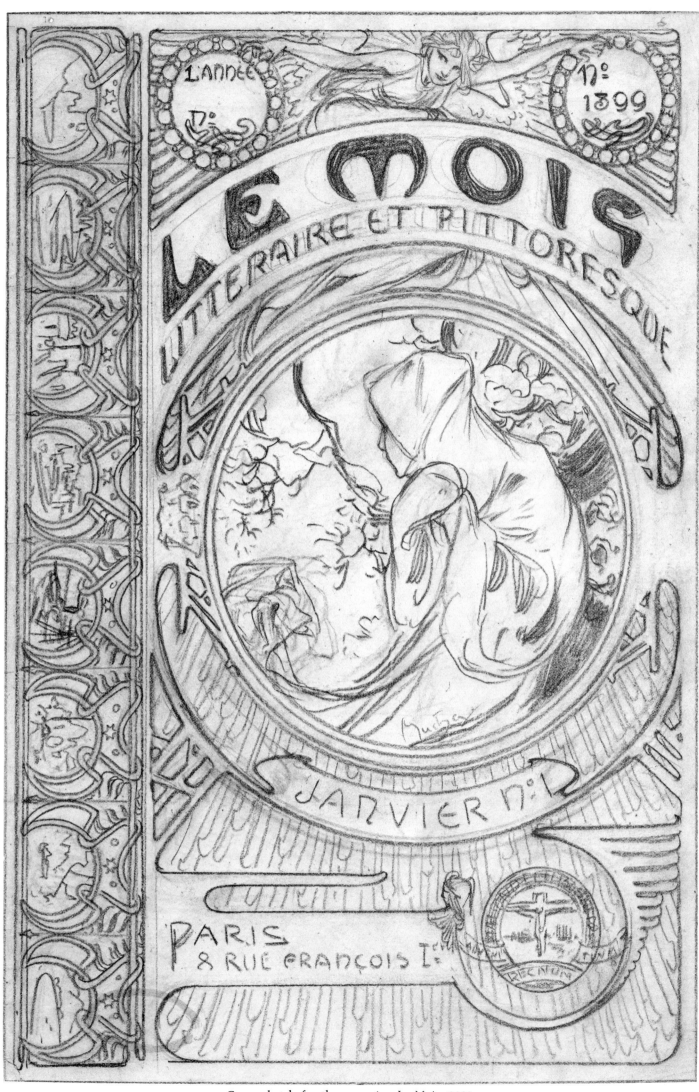

Cover sketch for the magazine *Le Mois*. 1898.

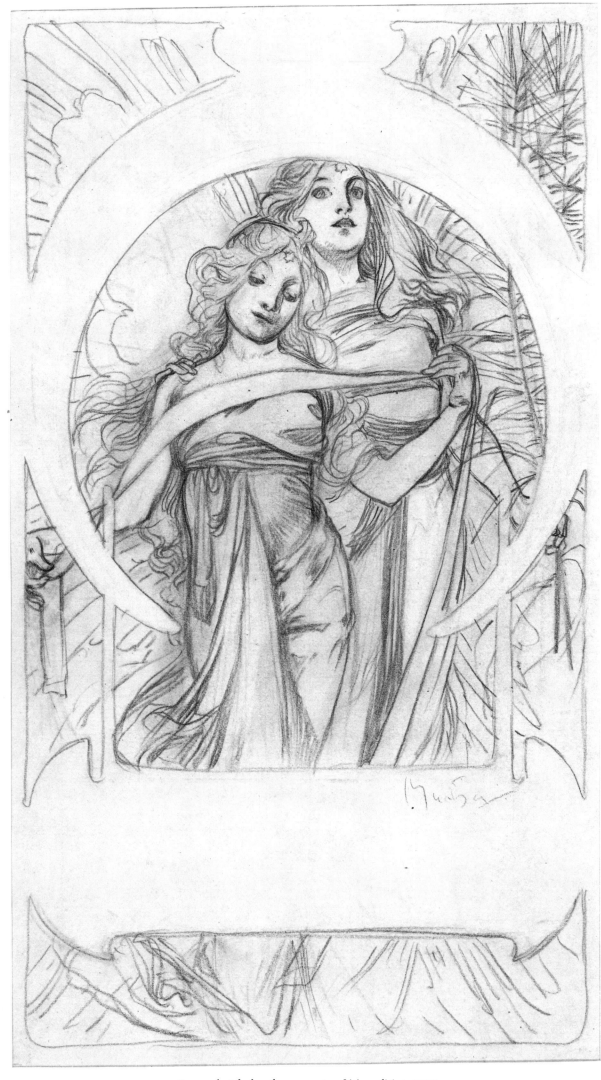

Cover sketch for the magazine *L'Age d'Art*. 1898.

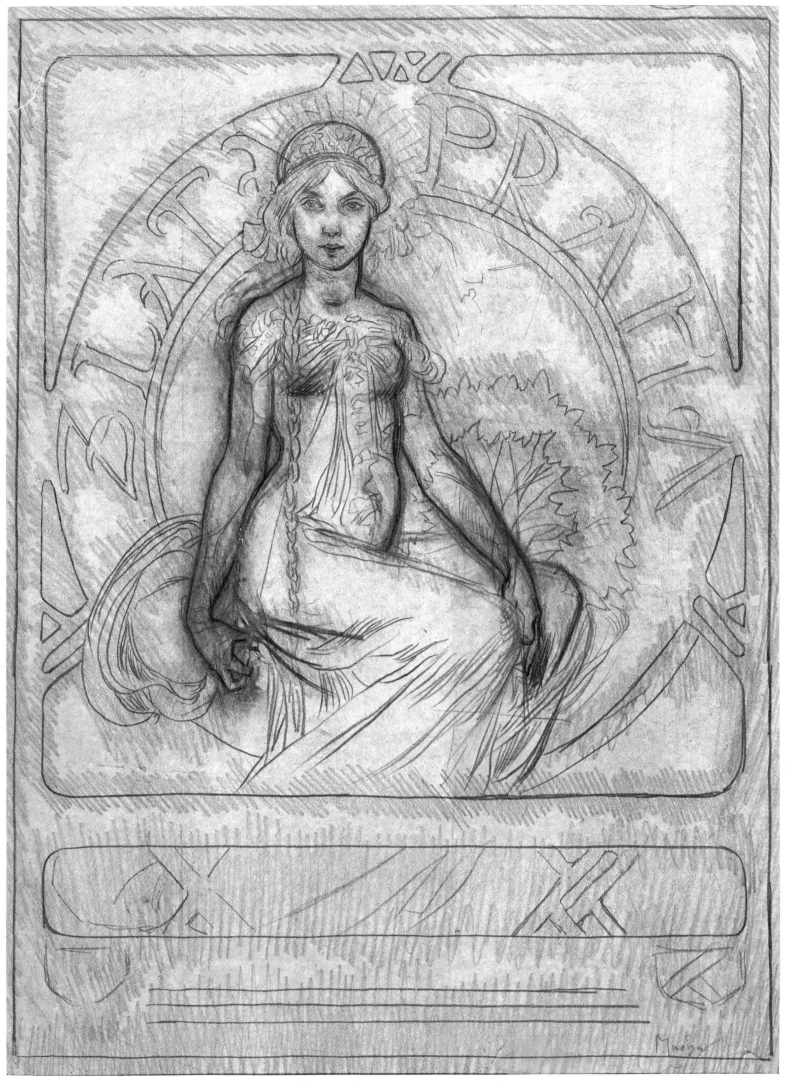

Cover sketch for the magazine *Zlatá Praha*. 1890s.

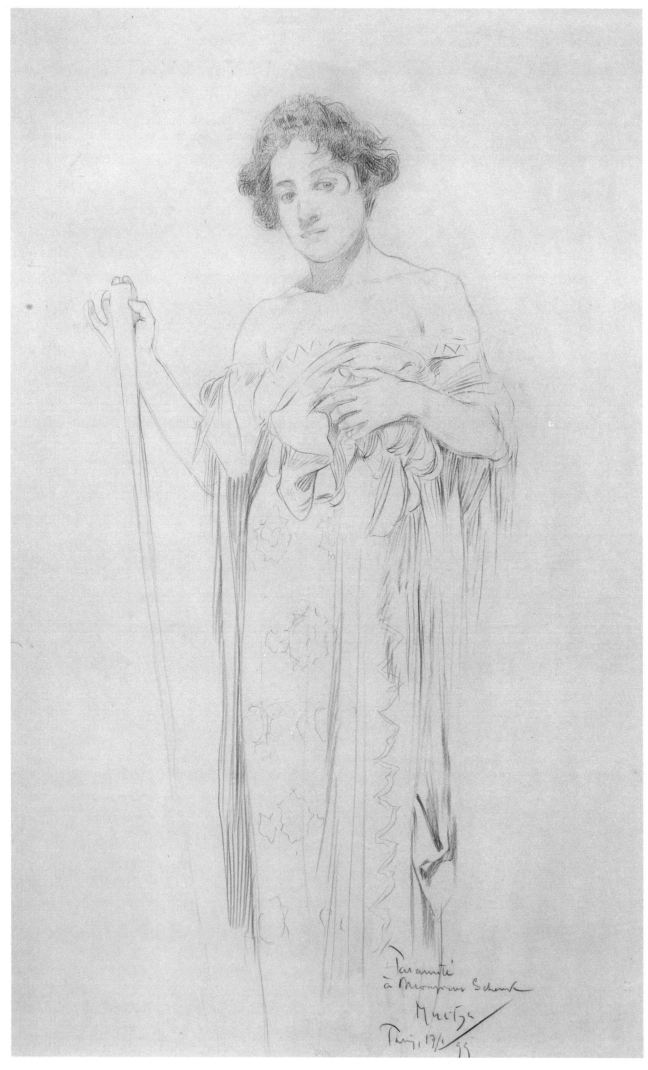

Woman with a billiard cue. 1899.

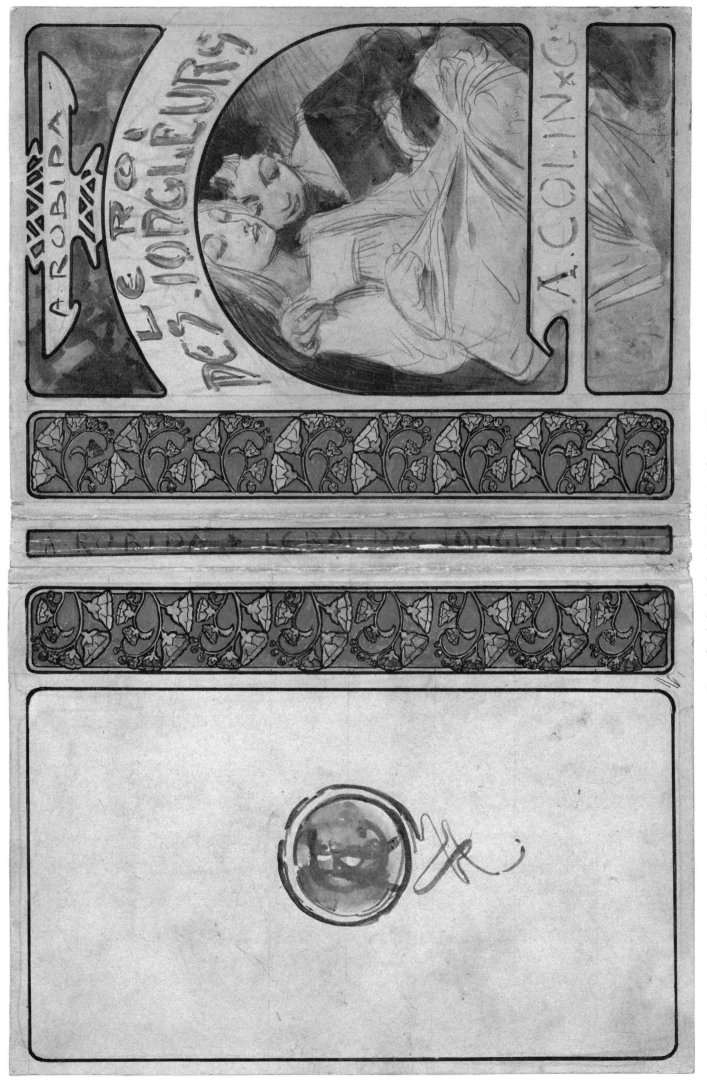

Cover sketch for the book *Le Roi des jongleurs*. 1898.

25

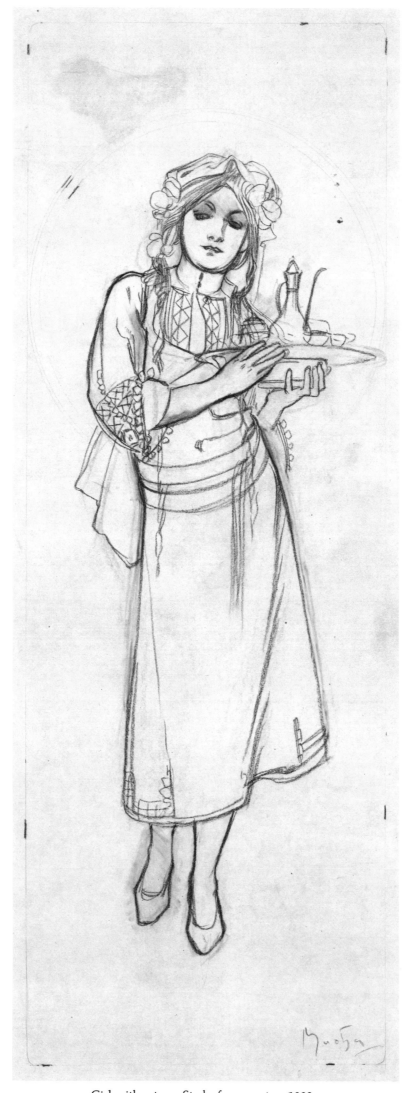

Girl with a tray. Study for a poster. 1899.

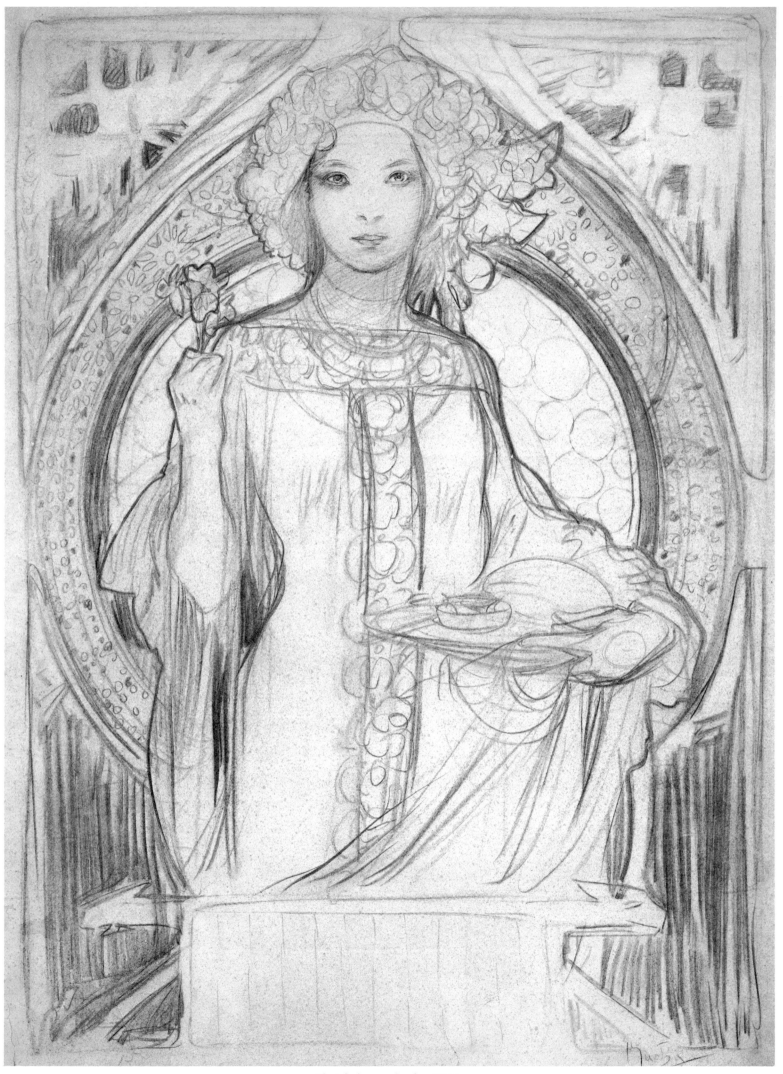

Sketch for a calendar. 1898.

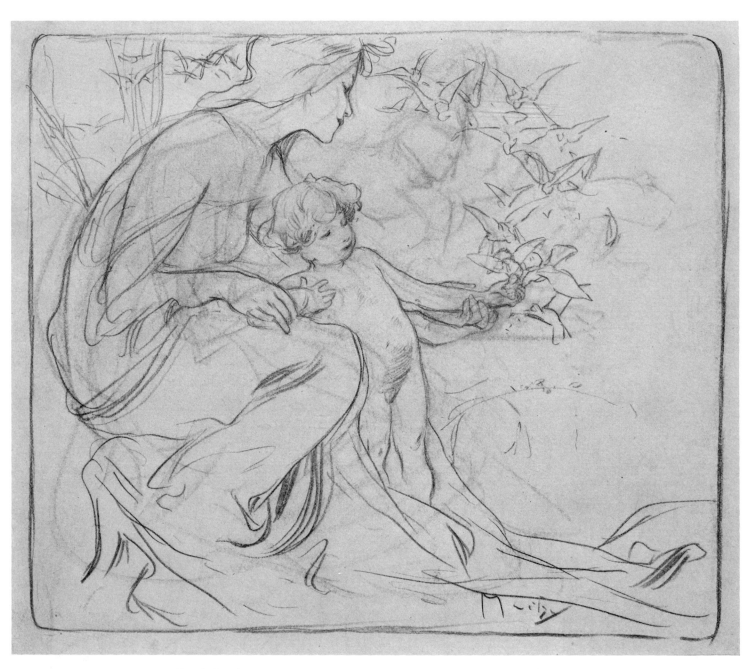

Sketch for the program of a charity performance by Sarah Bernhardt. 1899.

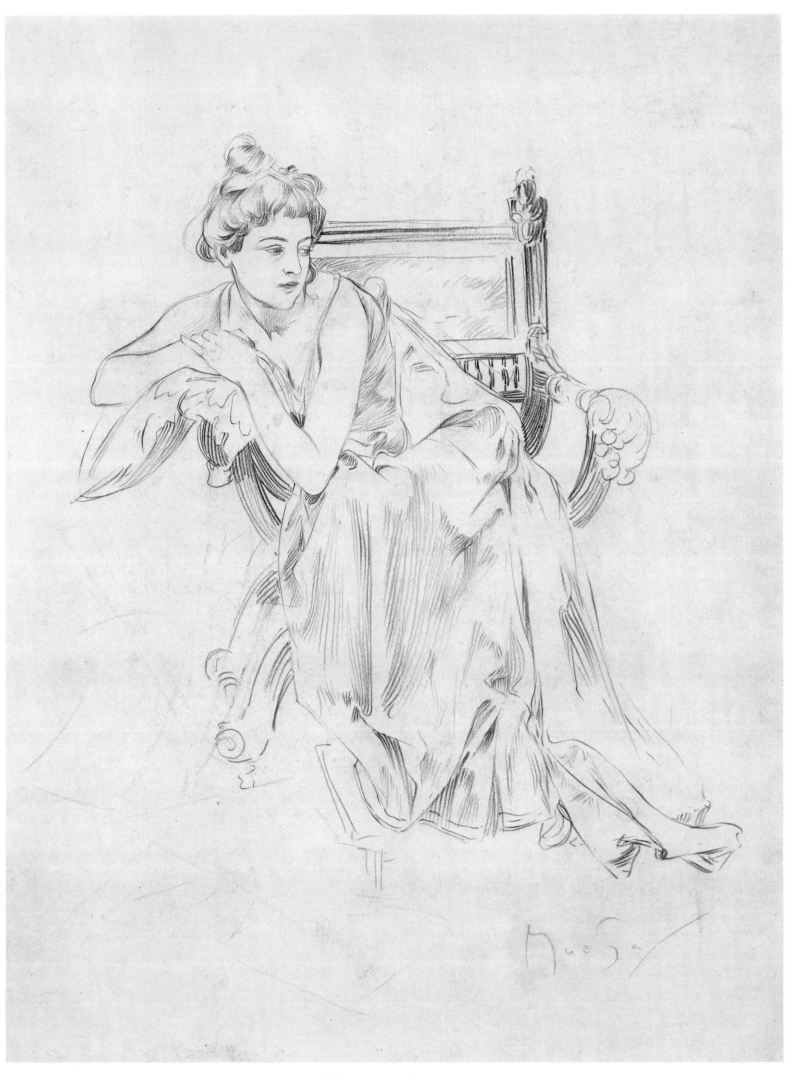

Girl in an armchair. 1899.

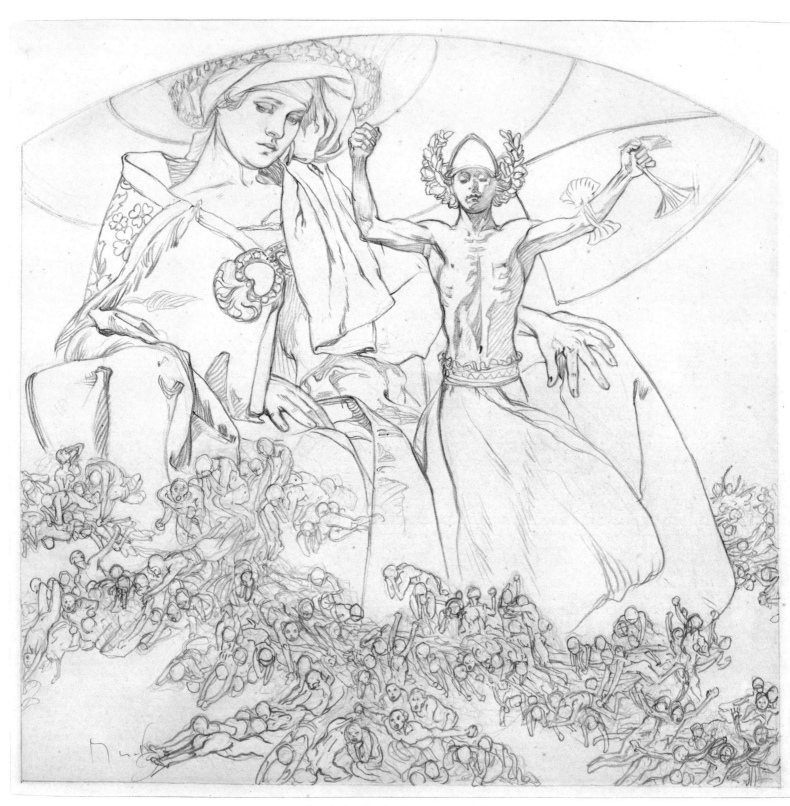

Sketch for the book *Le Pater*. 1899.

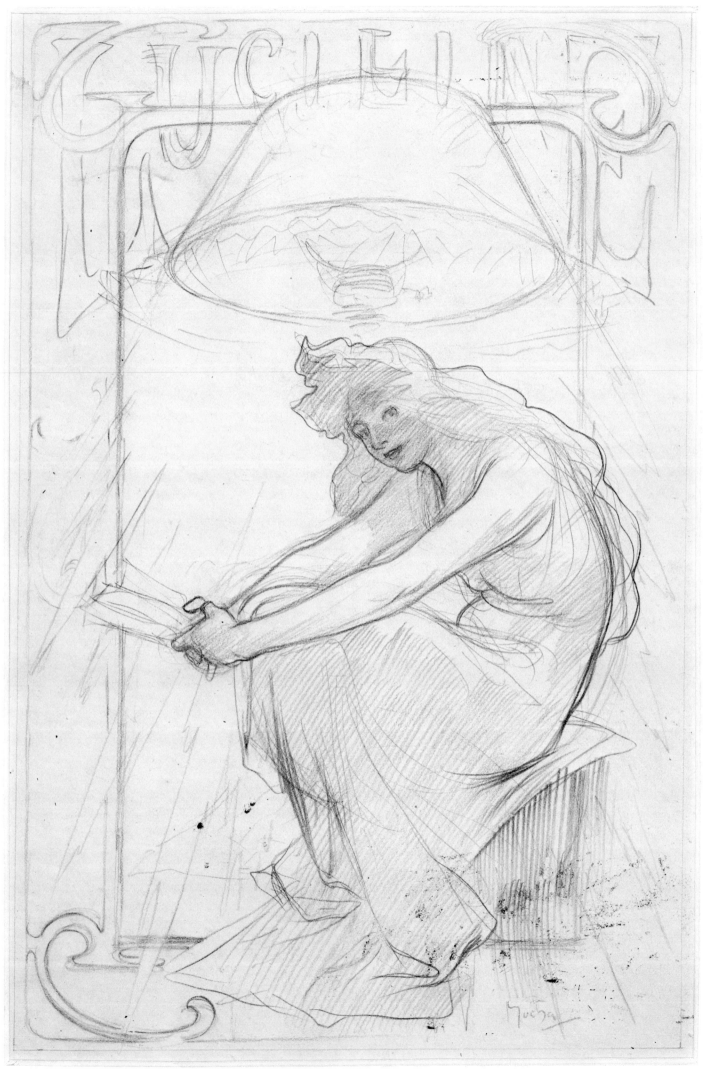

Girl under a lampshade. Advertisement for "Luciline." Late 1890s.

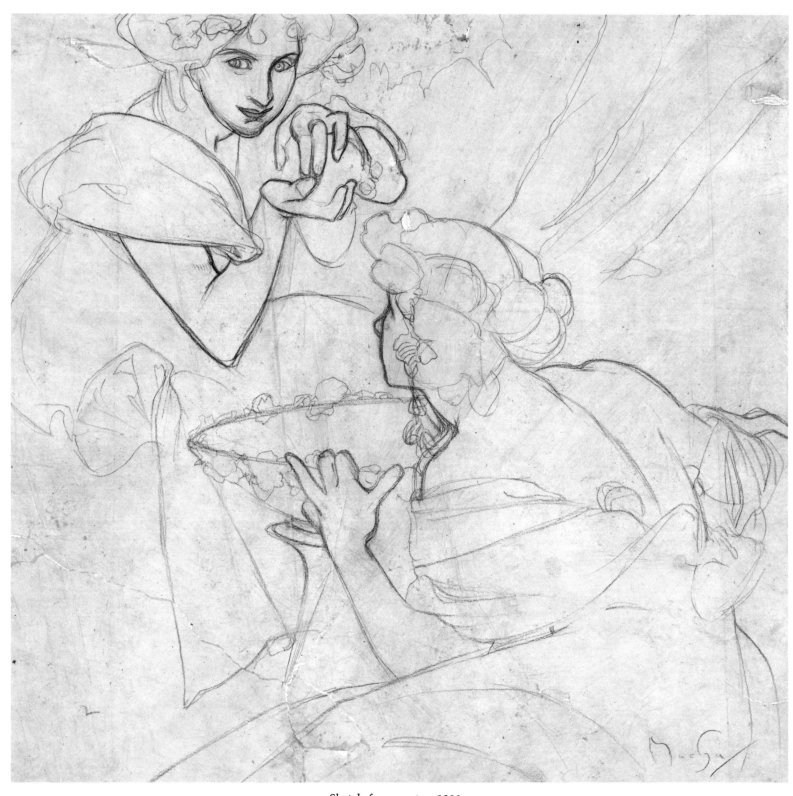

Sketch for a poster. 1900.

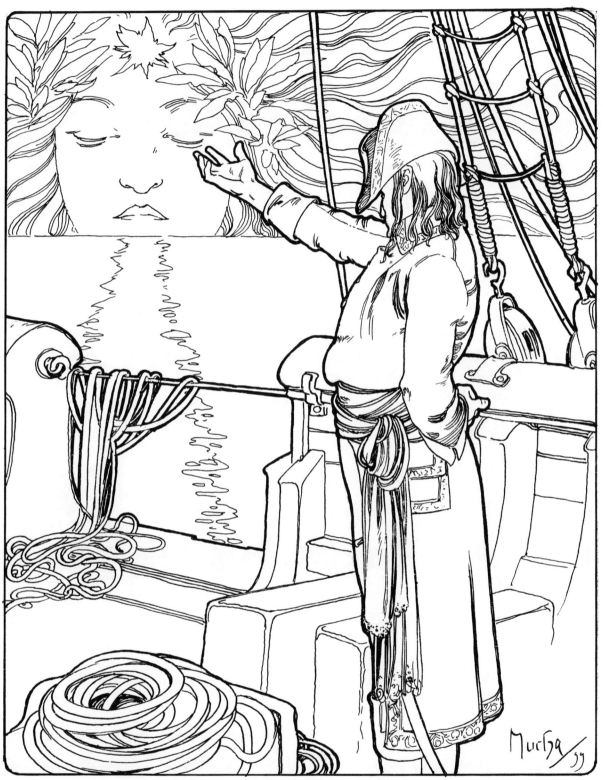

Illustration for the book *Clio*. 1899.

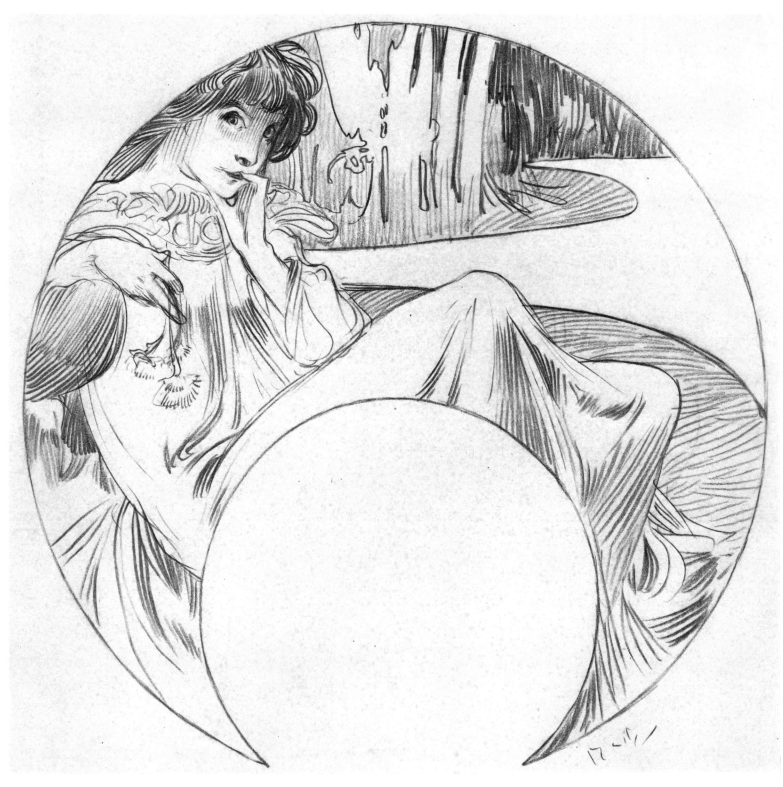

Sketch for a calendar. 1900.

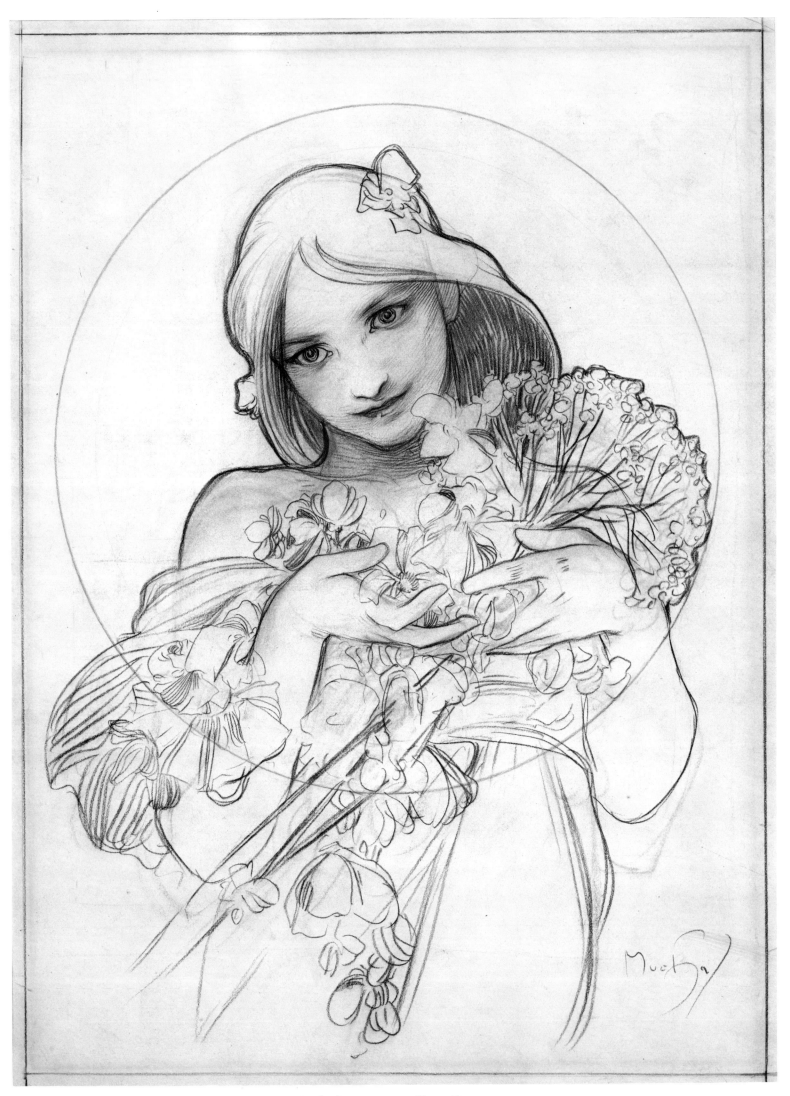

Study for a *panneau décoratif*. 1900.

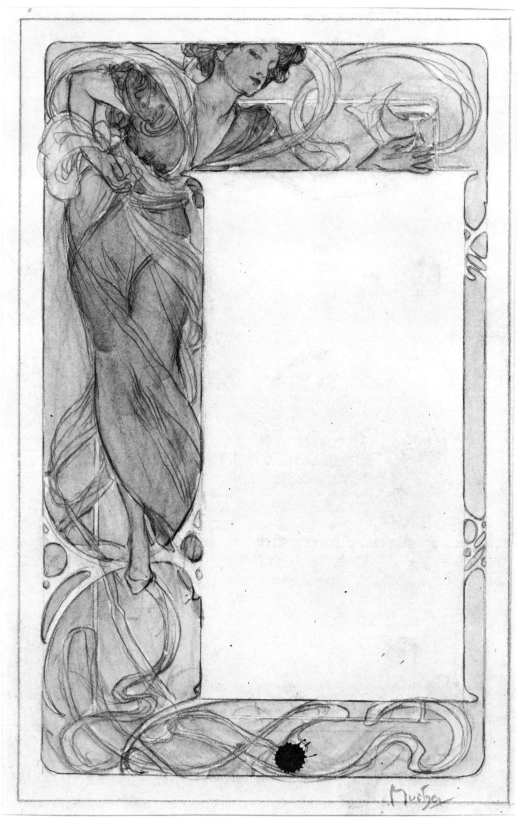

Sketch for a menu. 1900.

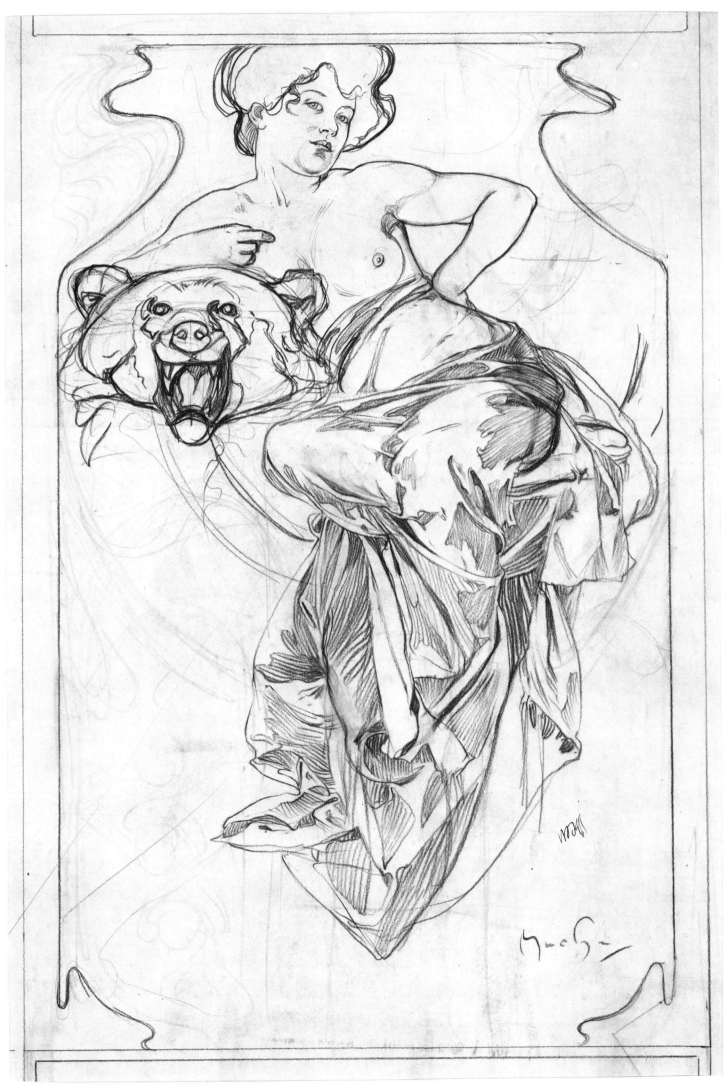

Study for a plate in the portfolio *Documents décoratifs*. 1900.

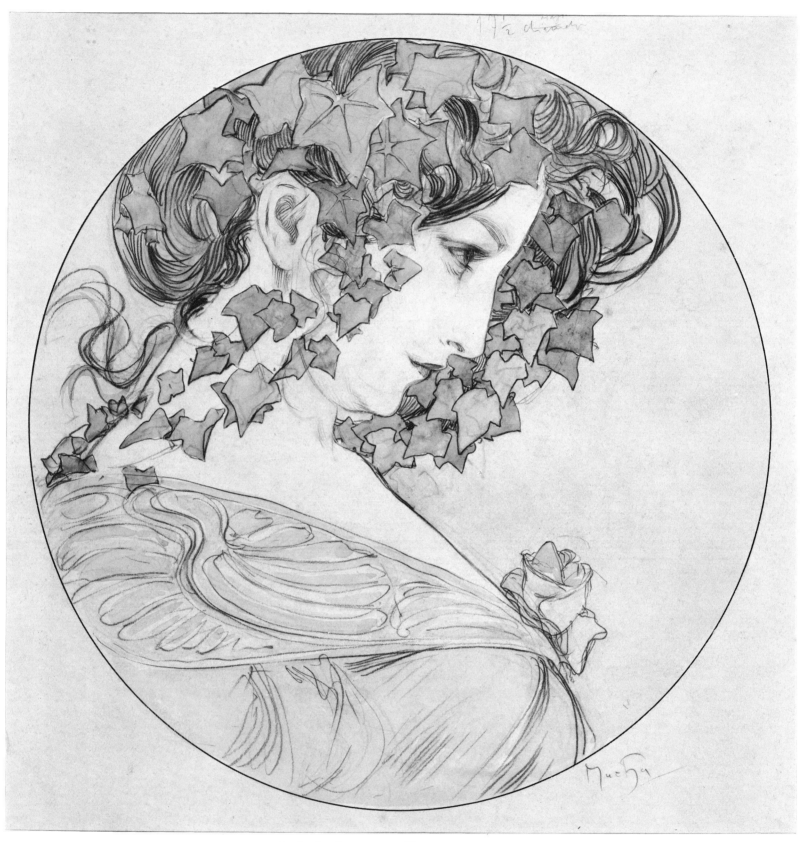

Study for the *panneau décoratif* "Ivy." 1901.

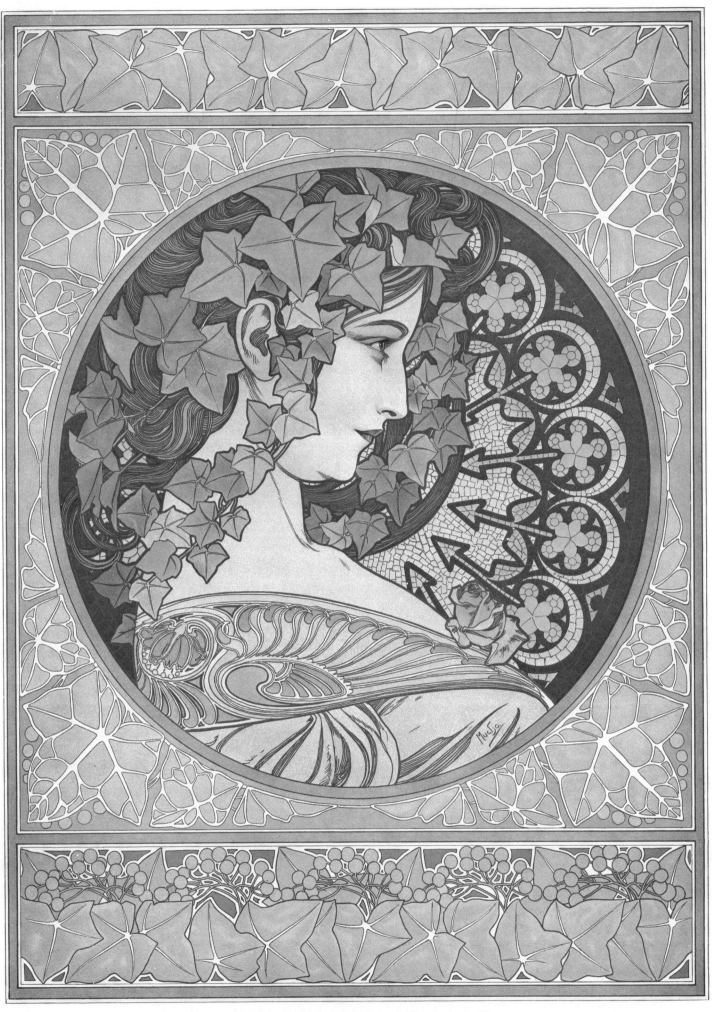

"Ivy." The lithographed *panneau décoratif.* 1901.

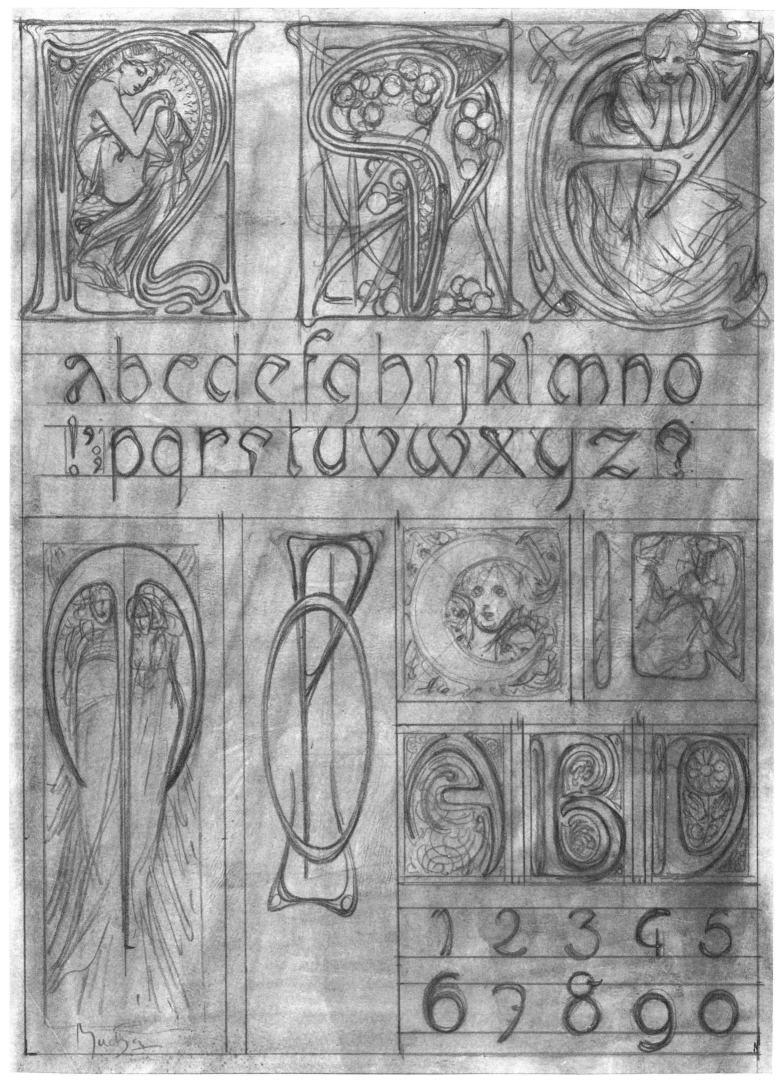

Study for a plate in the portfolio *Documents décoratifs*. 1901.

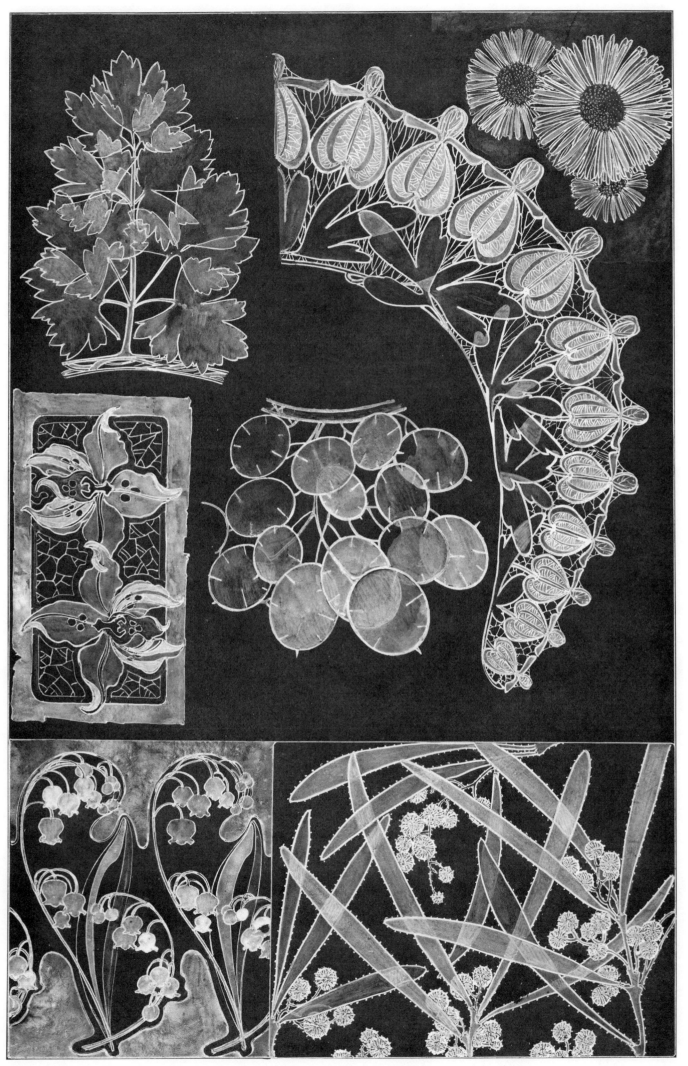

Study for a plate in *Documents décoratifs*. 1901.

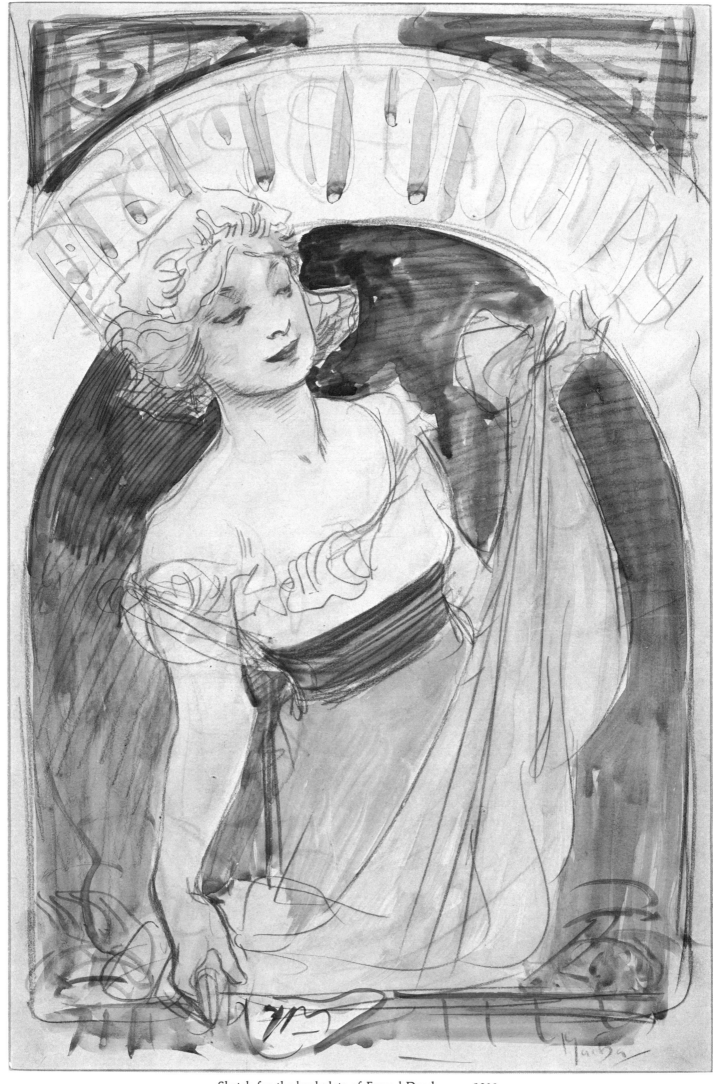

Sketch for the bookplate of Freund-Deschamps. 1900.

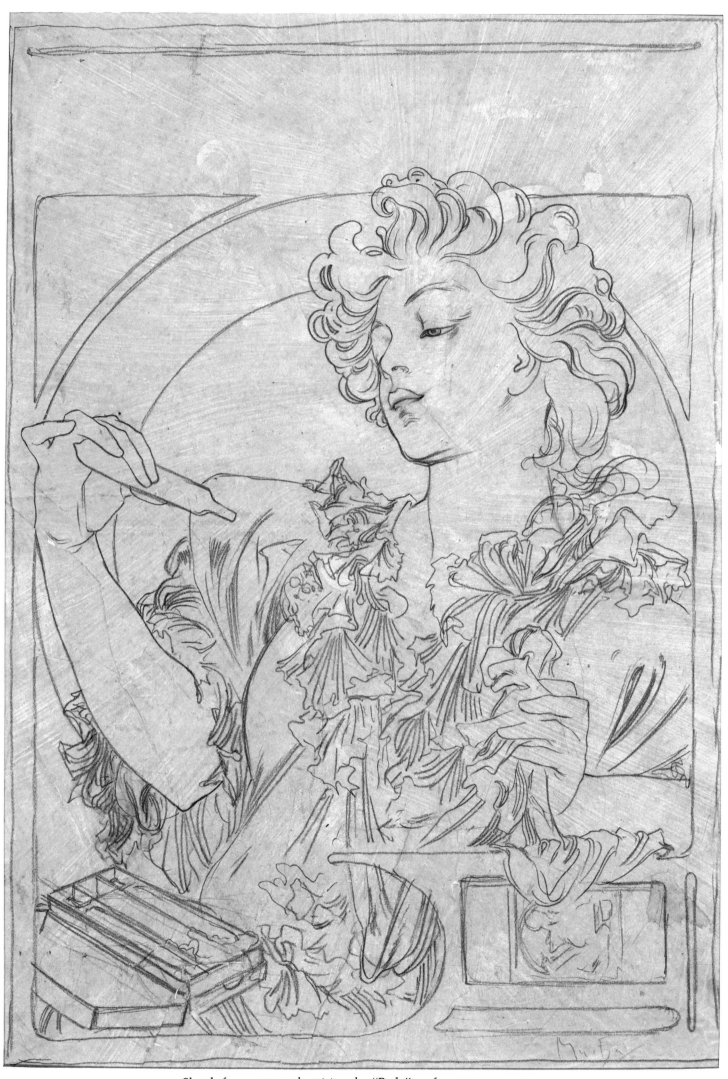

Sketch for a poster advertising the "Rodo" perfume sprayer. 1901.

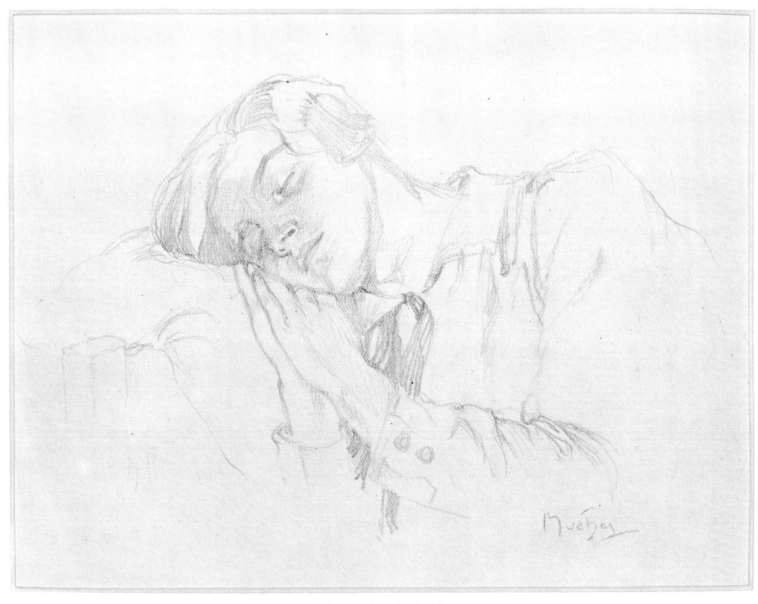

Sleeping boy. Undated.

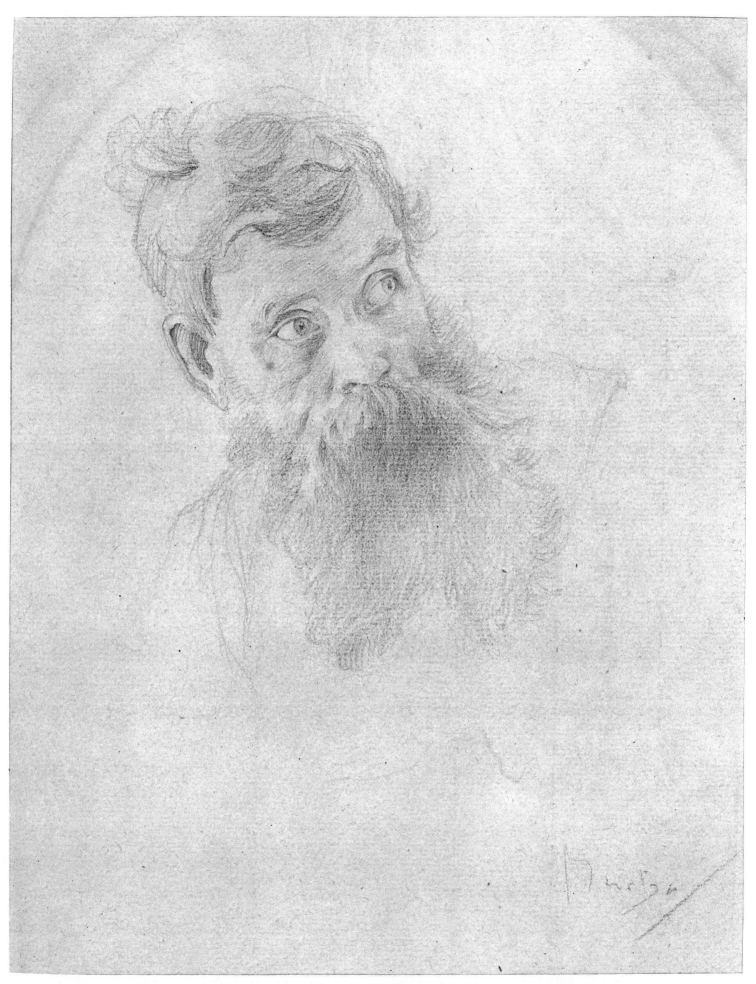

Head of a man. Undated.

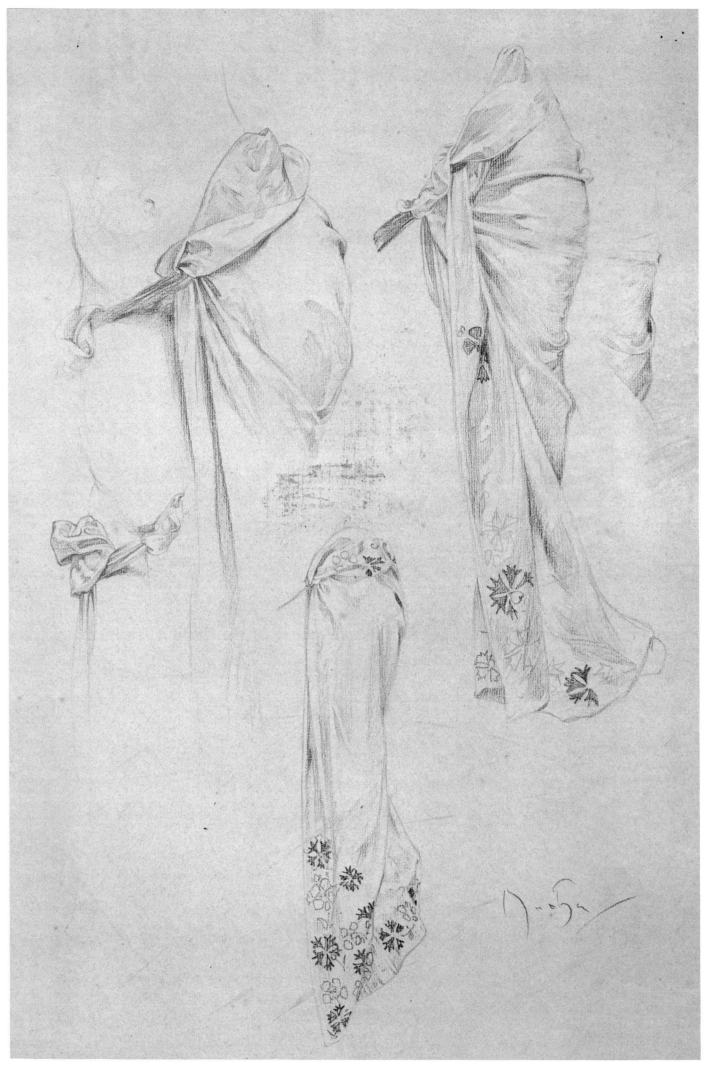

Studies of drapery. 1902.

46

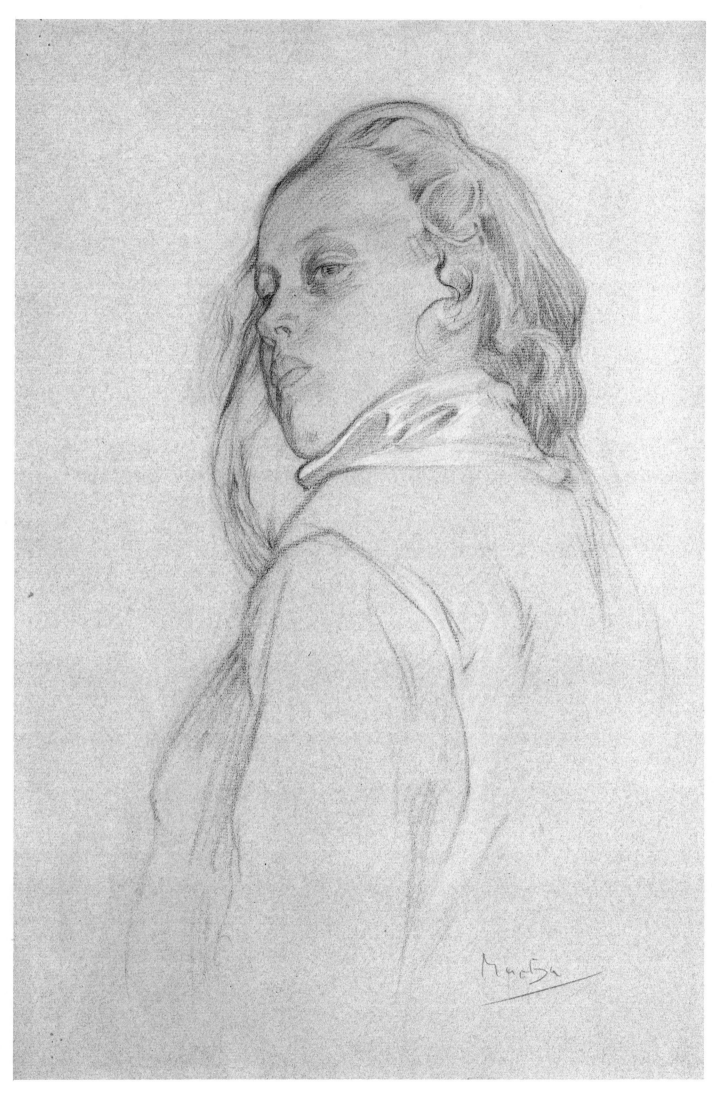

Study of a young woman. Undated.

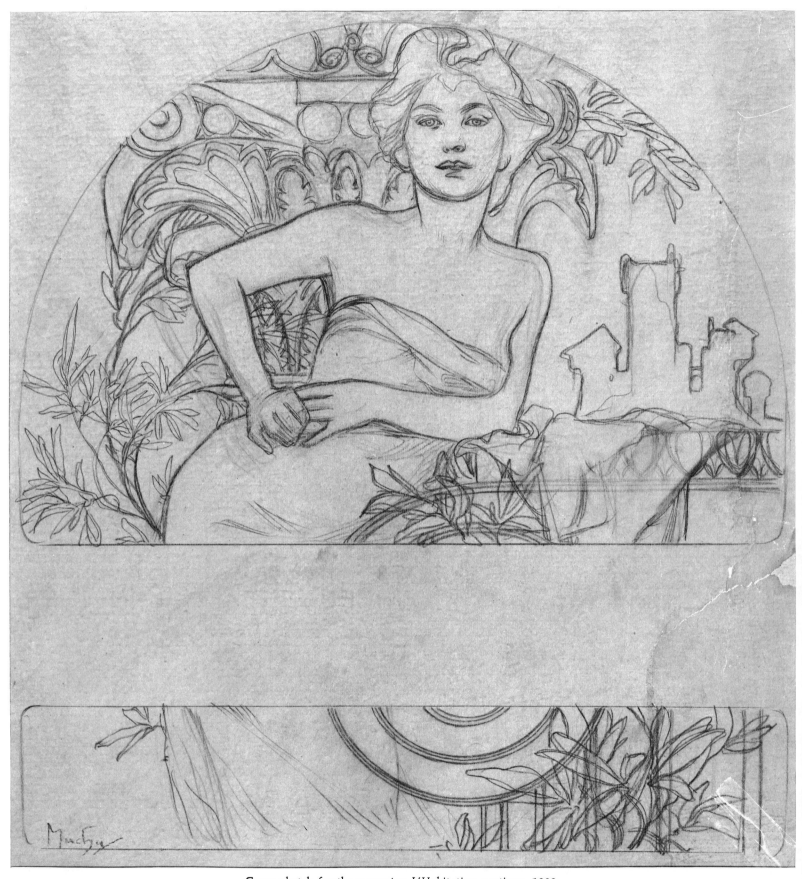

Cover sketch for the magazine *L'Habitation pratique*. 1903.

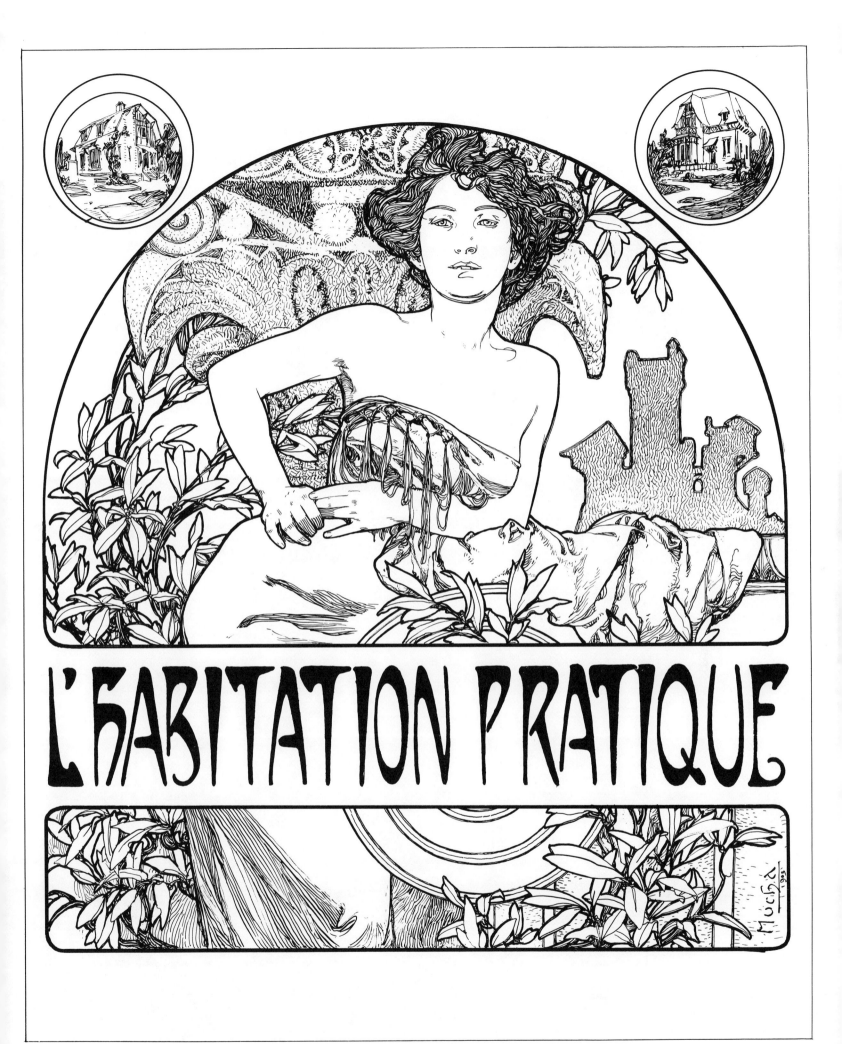

L'HABITATION PRATIQUE

Finished drawing for the cover of *L'Habitation pratique.* 1903.

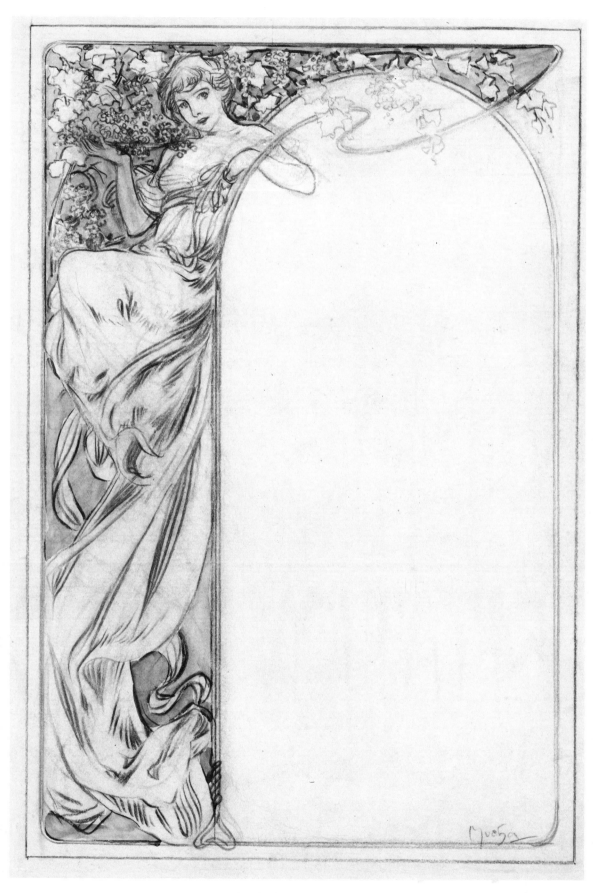

Sketch for a menu. 1903.

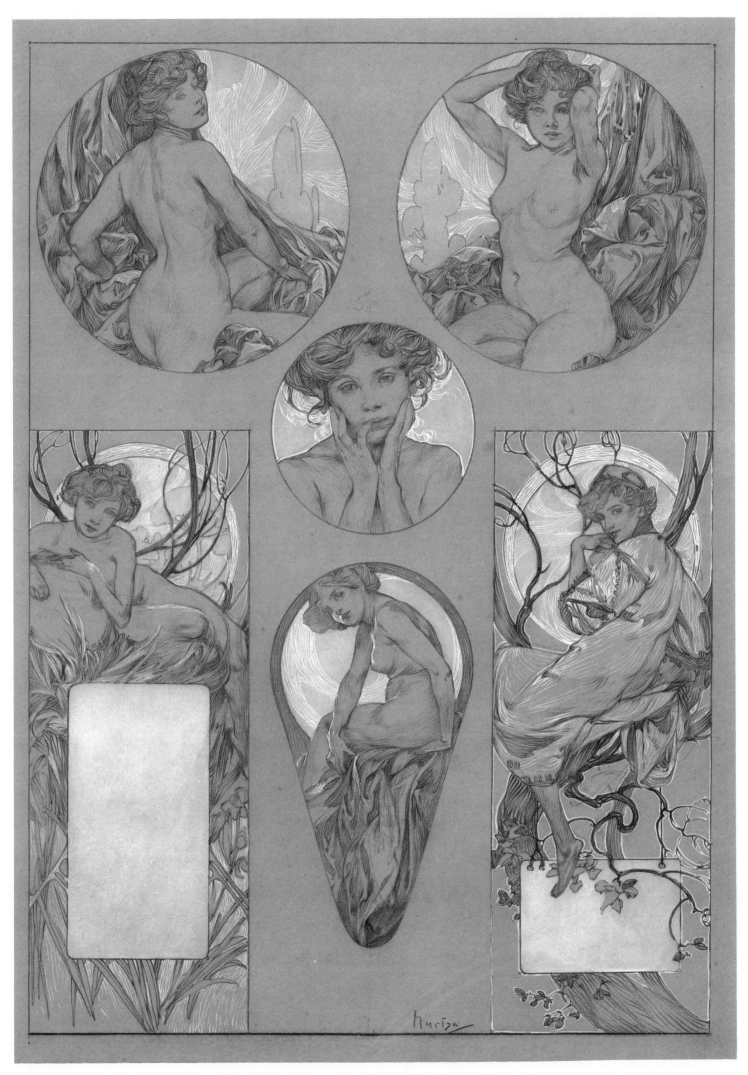

Finished drawing for a plate in the portfolio *Figures décoratives*. 1901.

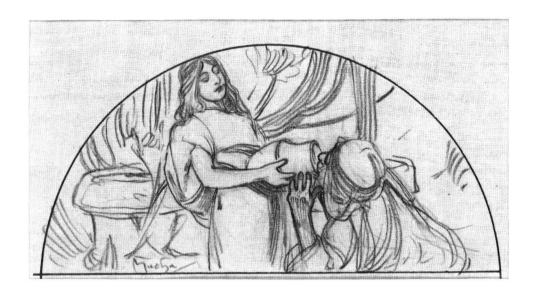

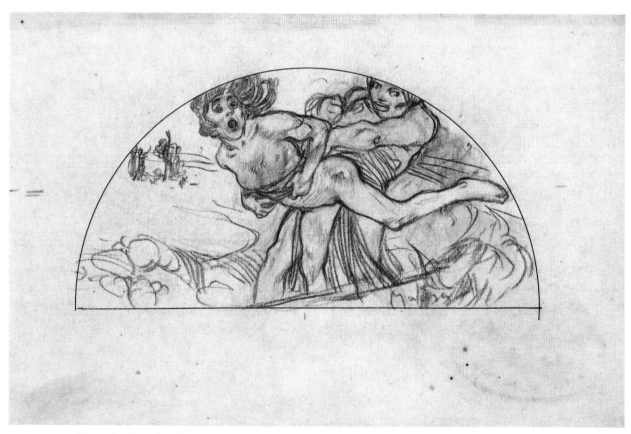

Two sketches for illustrations in the book *Au Son des cloches de Noël et de Pâques.* **1901.**

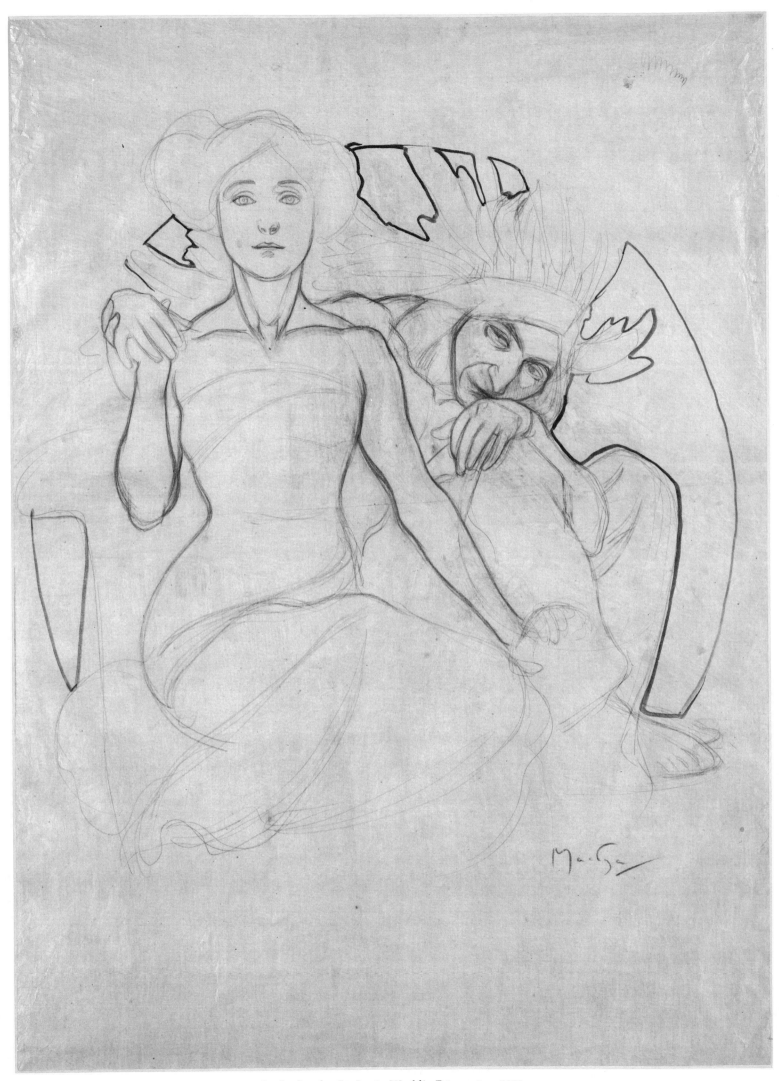

Study for the St. Louis World's Fair poster. 1903.

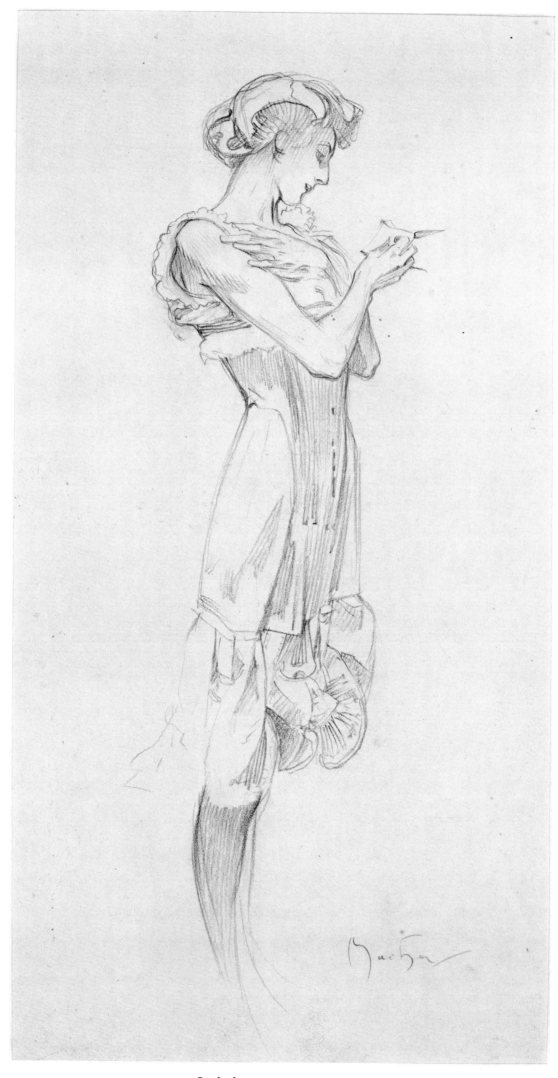

Study for a corset poster. 1909.

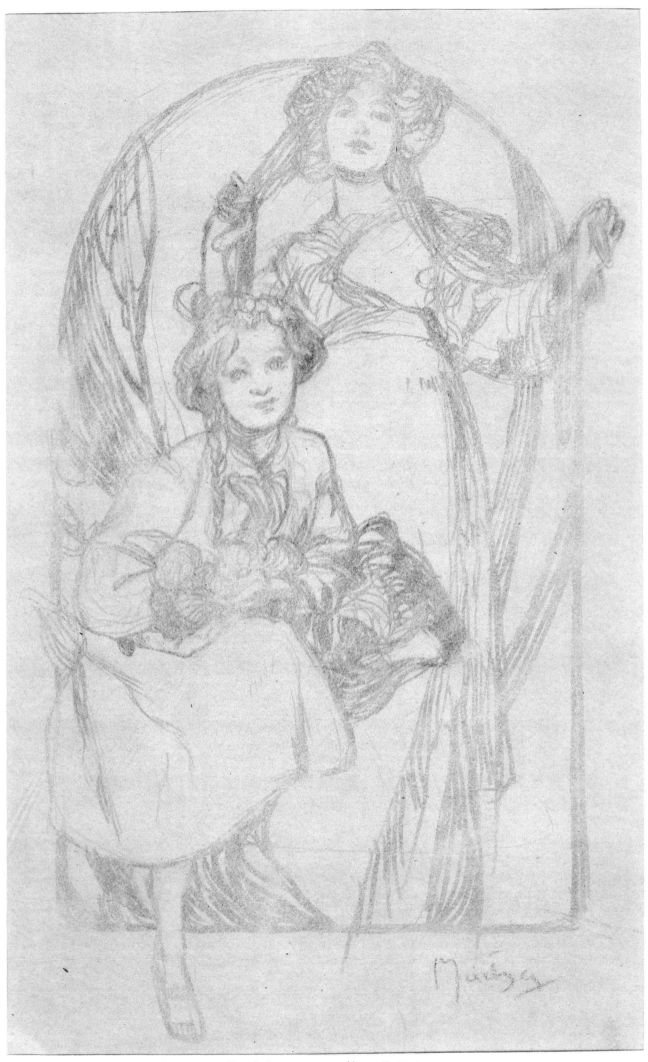

Sketch for a *panneau décoratif*. 1909.

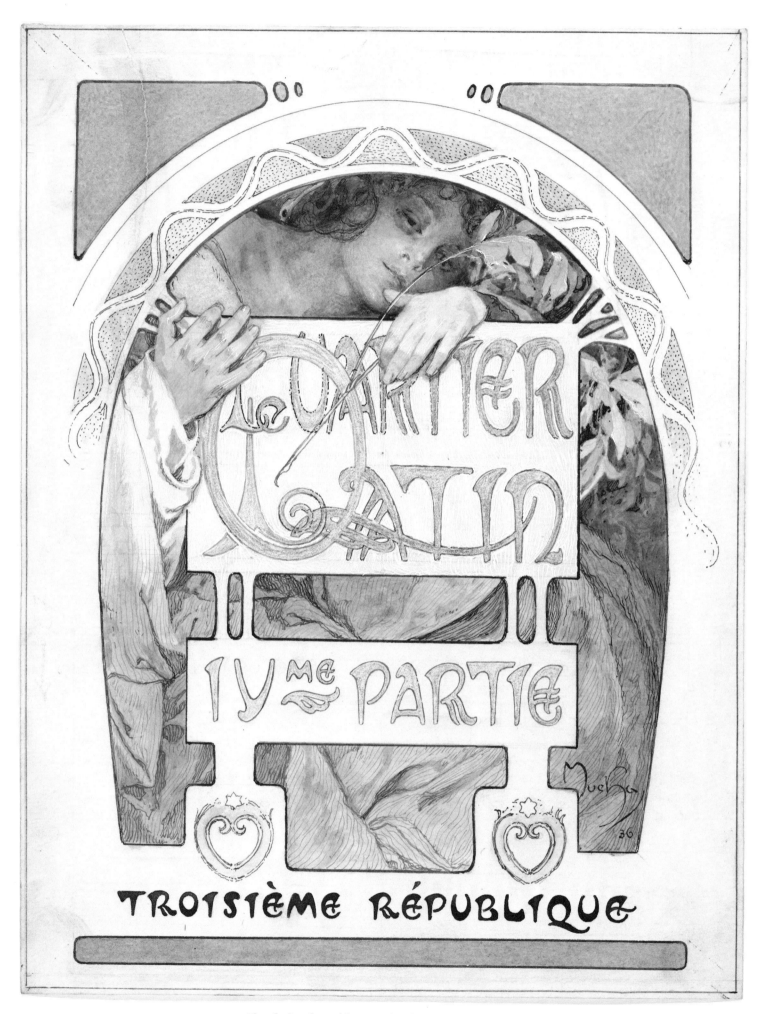

Sketch for the publication *Le Quartier latin*. 1936.

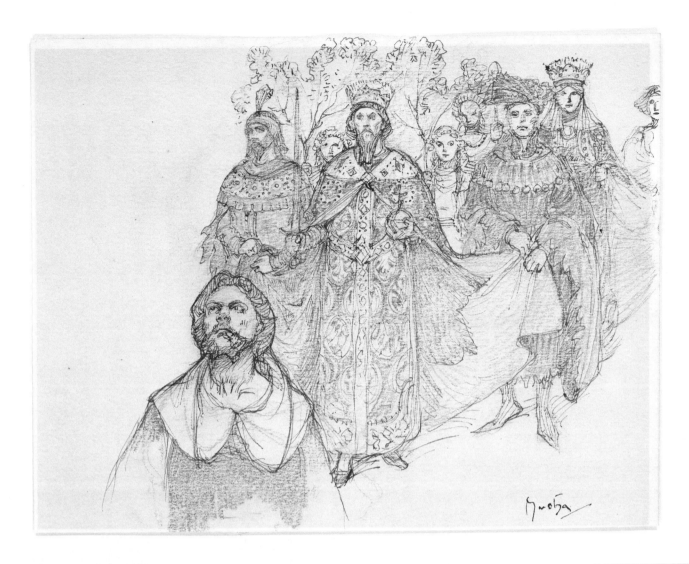

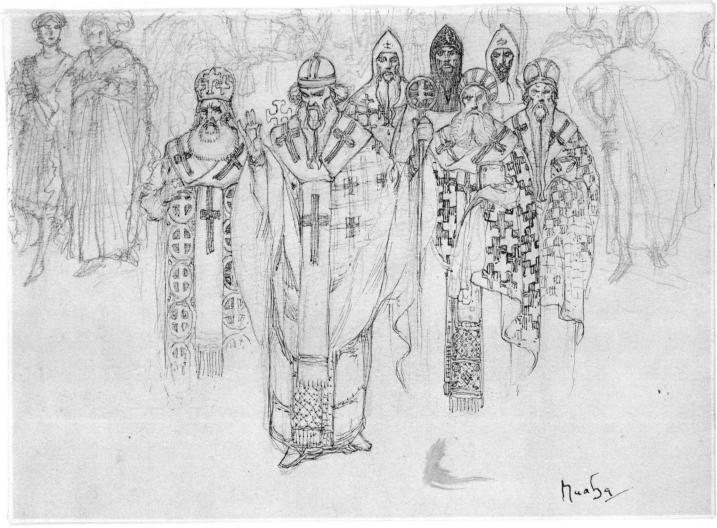

Two sketches for the painting *The Coronation of Dushan*. By 1925.